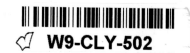
HOW TO
DRAW AND
PAINT
FANTASY
COMBAT

HOW TO DRAW AND PAINT FANTASY COMBAT

Matt Stawicki

Text by
Finlay Cowan

BARRON'S

A QUARTO BOOK
First edition for North America
published in 2014 by Barron's
Educational Series, Inc.

Copyright © 2014 Quarto Inc.

All inquiries should be
addressed to:
Barron's Educational
Series, Inc.
250 Wireless Boulevard
Hauppauge, New York 11788
www.barronseduc.com

ISBN: 978-1-4380-0346-7

Library of Congress Control
Number: 2013936227

QUAR.HDPC

Conceived, designed,
and produced by
Quarto Publishing plc
The Old Brewery
6 Blundell Street
London N7 9BH

Project Editor: **Victoria Lyle**
Art Director: **Caroline Guest**
Designer: **John Grain**
Copyeditor: **Cathy Meeus**
Proofreader: **Julie Brooke**
Indexer: **Helen Snaith**
Picture Researcher: **Sarah Bell**

Creative Director: **Moira Clinch**
Publisher: **Paul Carslake**

Color separation by Pica
Digital Pte Ltd, Singapore
Printed by Toppan Leefung
Pte Ltd, China

9 8 7 6 5 4 3 2 1

CONTENTS

FOREWORD

Drawing always has been, and always will be, a passion of mine. From the works of Frank Frazetta to the movies of George Lucas, I've found inspiration in what I see and have wanted to create my own works of art.

From an early age I was fascinated by dinosaurs and dragons and spent much of my time drawing these incredible creatures. As I got older, superheroes became more of my focus, with the Hulk and the Flash among my favorites. Movies and television also played a huge role in fueling my creativity, especially gems like *Star Trek*, *Buck Rogers*, *Heavy Metal*, and *Star Wars*.

At college I learned everything I could about traditional painting techniques while feeding my fantasy interests outside of school with music, movies, and fantasy art. After college I was lucky enough to embark on a career as a professional artist.

This book represents some of the basic ideas and concepts I have learned over the years. It is my hope that this will offer a starting point and guide to those who are starting out and share my love of fantasy art. And for those who are further developed artistically, I hope this will help reinforce some of the basic ideas and concepts and inspire the development of new ones. However, my main piece of advice to aspiring artists is to stay observant and practice, practice, practice!

Matt Stawicki

ABOUT THIS BOOK

This book teaches everything you need to know about drawing fantasy combat art, taking you through the tools and materials you will need, human anatomy and drawing dynamic figures, to choreographing battle scenes. It is filled throughout with inspirational paintings by professional artists and finishes with four step-by-step artist-at-work sequences.

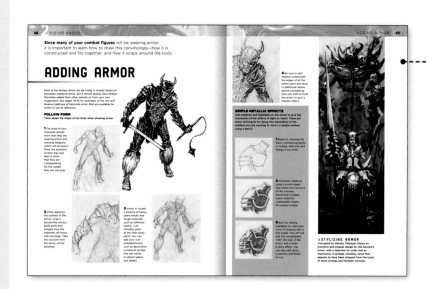

Chapter 1
Tools and techniques

This chapter takes you through the basic art supplies you will need to get started, including the pros and cons and effects of each, giving you the confidence to make informed decisions.

Chapter 2
Figure basics

At the heart of combat scenes are figures fighting with one another. In order to depict figures in extreme, entwined poses it is important to understand the basics, which this chapter teaches you.

Chapter 3
Making your combat scenes real

This chapter teaches you how to bring your charaters and battle scenes to life. It includes directories of poses, characters, and weapons to use as inspiration and reference.

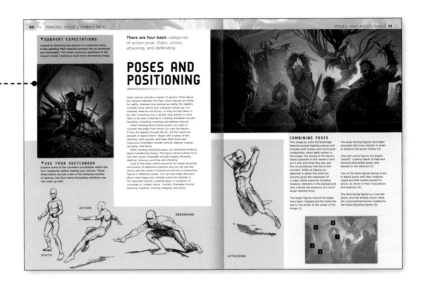

Chapter 4
Fantasy genres

This chapter takes you through the different fantasy genres with reference to iconic films, books, and artworks. It analyzes the sort of details to include to make your paintings really authentic, including weapons, clothing, architecture, nature, transportation, and palette.

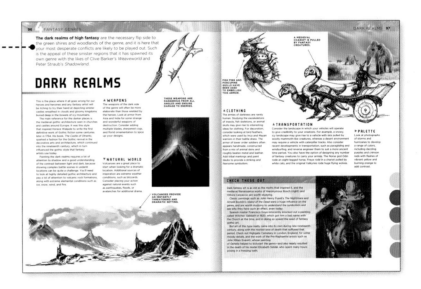

Chapter 5
Artists at work

Look over the shoulder of four professional artists as they create their artworks, with step-by-step photos and text that explains what they are doing, why, and how.

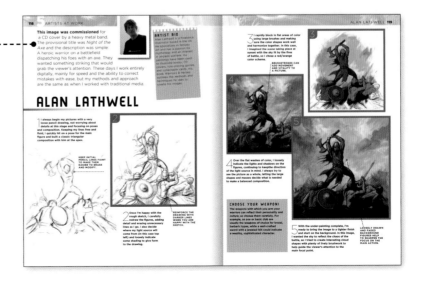

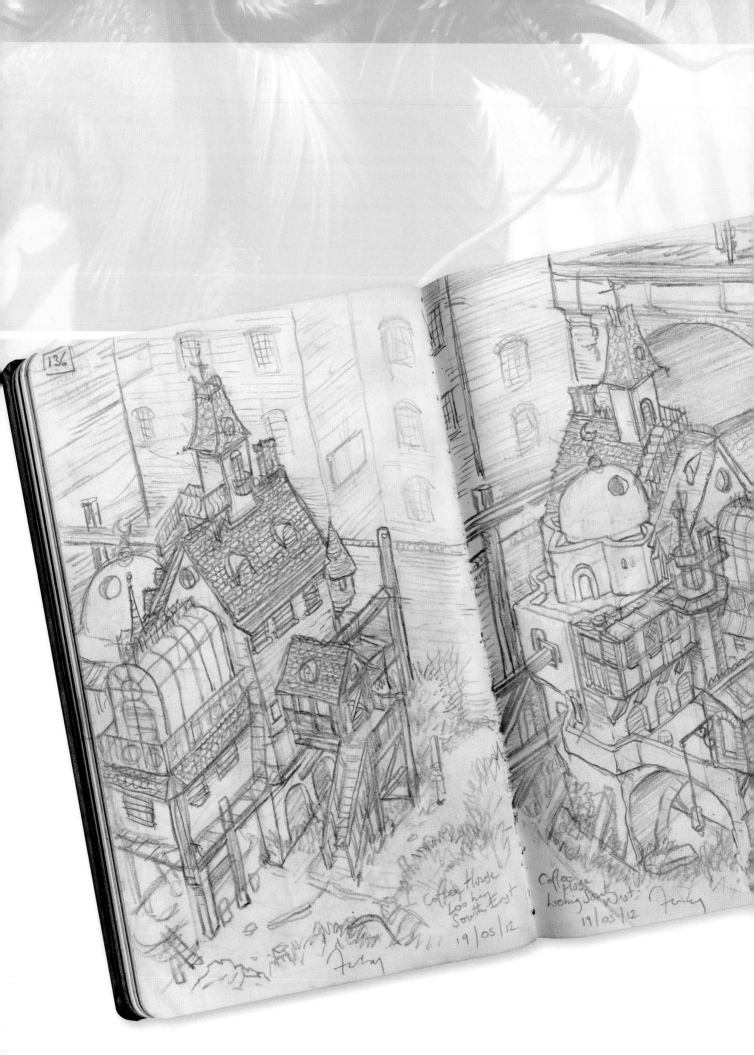

136

Coffee House
Looking
South East
19/05/12
Farley

Coffee Plaza
Looking South
West
19/05/12
Farley

TOOLS AND TECHNIQUES

1

"We shall not fail or falter; we shall not weaken or tire. Neither the sudden shock of battle nor the long-drawn trials of vigilance and exertion will wear us down. Give us the tools and we will finish the job."

Sir Winston Churchill (1874–1965)
radio speech, 1941

Any aspiring artist can be forgiven for thinking that "everything has gone digital" and there is little need for the old-fashioned pencil-on-paper skills that have served artists since time immemorial. Wherever you look in the creative industries, you see accomplished artists dashing off their masterpieces with an array of sophisticated technological tools.

DRAWING MEDIA

The simple truth is that these industries still rely upon, and indeed demand, that artists, no matter what their role, can get their ideas down quickly and effectively with a pencil and paper. So don't fool yourself into thinking that you can't make progress until you have all the latest shiny technologies to aid you— if you can't draw, it will always show in the final work, no matter how many layers of effects you add to it.

The good news is that pencils and paper are cheap and easy to get hold of, no matter what your circumstances, and, unlike an iPad, they don't run out of power just as you have a brilliant idea on the bus or train. There is a whole world of different drawing media to choose from, and you can indulge yourself endlessly trying out different pencils without going to a great deal of expense. Just try a few different products until you find the ones that suit your style best.

There are plenty of other drawing media, including colored pencils, charcoal, conté, and pastels. Different artists use different drawing materials for their work, and it's up to the individual to experiment and see what best suits their work. Even if you intend to be a fully digital artist, it is essential as part of your journey toward being a fantasy master that you try a wide variety of tools and media before focusing your range more narrowly.

◄WHERE THE MAGIC HAPPENS
Rapid pencil sketches, such as this one by John McCambridge, show how artists do all their thinking in the early stages as they plan out the composition of their artwork. Not only do the drawings show the structure of the piece, but they also serve to capture the energy and power that the artist wants to retain in the final artwork. Artists will often produce dozens of these sketches in quick succession as they rush to keep up with the flow of inspiration from their fertile imaginations!

DRAWING MATERIALS

SOFT PENCILS

Soft pencils range in hardness (or softness) from B through 9B. These are great for working with tone and shadow and, because they are very expressive, for throwing down rough ideas in your sketchbook. Soft pencils tend to smudge and this can work to your advantage, causing unexpected effects and details to appear in your work. Soft pencils will also give a much blacker tone than hard pencils, so they are good for producing finished art.

HARD PENCILS

Hard pencils range in hardness from HB through 9H. Hard pencils are used for producing highly detailed work and are ideal for developing complex designs. They don't smudge, so they are useful for laying out work that will later be painted or inked, but they are not as expressive as soft pencils and there is less room for experimentation when using them.

▲ MAKE YOUR MARK

Use a mixture of pencils to experiment with as many different marks and textures as you can think of. Why? Because you will only know what suits you when you've tried everything— and you never know, you may invent a completely new style of drawing.

SHARPENERS

Needless to say, a pencil sharpener is necessary, but many people would be surprised to hear that it's really worth spending a bit more money and buying the best quality metal sharpener you can find—it will make a difference and save you a lot of wasted graphite. Scalpels are good to have on hand but tend to be very wasteful. And you need to be careful with them; many graphic designers and fantasy artists have small scars on their thighs from when the scalpel has slid off their drawing board.

ERASERS

Hey, everybody makes mistakes, so let's accept it. You're probably going to spend more time erasing your work than actually drawing. So it's good to have a big, fat eraser for all those big, fat mistakes, and a small pencil eraser for fine work and picking out highlights.

TECHNICAL PENCILS

Technical pencils are often used by graphic designers, but they are just as useful to artists. They don't need to be sharpened, which allows you to draw more quickly, and they give a consistent thickness of line. These pencils come in a variety of barrel sizes and can be filled with graphite of a hardness of your choice. When loaded with soft graphite, they can give a surprising diversity of line and can be very expressive to work with.

BIG FAT CHUNKY PENCILS

Chunky pencils often put younger artists off as they may seem infantile, but they are one of the best tools for really letting go and allowing your imagination to flow. You can choose from solid graphite pencils or wood-barrelled ones. They give an immense range of line thickness and expressions. It's invaluable for any artist to experiment with all the different types of marks.

DRAWING PAPERS

Cartridge paper comes in rough and smooth finishes. Rough finishes are good for working with soft pencil and generate a lot of tone without a huge amount of pencil coverage. Smooth paper is better for more detailed work. Bristol Board and other cards tend to be polar white and allow you to produce sharp, clean lines. They are great for when you want to use inks or convert your pencil work in Photoshop to make digital paintings.

You never know when you might have a brilliant idea on the bus or standing in line at the bank. Young artists tend to think they will remember everything, but this is not as easy as many people think.

KEEPING A SKETCH PAD

When your head is full of ideas, there is no space for new ones, so it's important to get those thoughts down right away so you can clear your mind and move on to the next thing. Great ideas are like seeds. They start off small and often don't look like they will amount to much. But with careful nurturing, a seemingly insignificant thought can grow from a fleeting notion to the artistic equivalent of a mighty oak with the potential to change the course of your career.

So it is vitally important to keep a record of your ideas—all of them, no matter how silly or weak they seem. Somewhere in the midst of your random scribblings you may find the key to your future.

Portable, cheap, and easy to use, a sketchbook is the perfect medium for recording your thoughts. There are a million different types on the market, so it's not difficult to find a size and quality that is right for you.

▲ DEVELOPING YOUR OWN THEMES

There is a simple rule that the more you repeat a drawing of the same character, costume, prop, or setting, the more it comes to life. So use your sketchbook to develop specific fantasy ideas by drawing them over and over again. Aspiring artists often make the mistake of settling for their first version of a design. Always try a few different versions, no matter how satisfied you are with the first, because further development will stretch your creative powers and will almost invariably produce a better result.

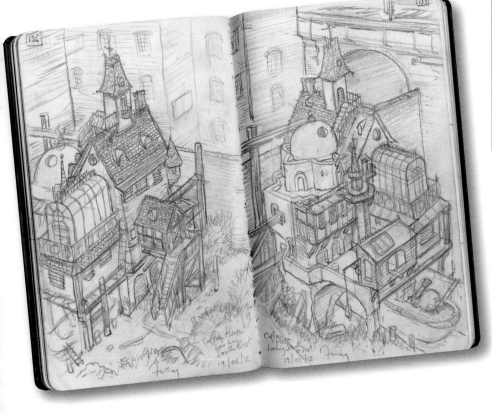

SKETCHING ON THE MOVE

Hardback sketchbooks are easier to use than softback types when you are on the move, providing a firm surface on which to work.

◄ LIFE DRAWING: PLACES

The more you draw, the more you see. Consider that old building you pass on the way to work or school every day and barely even notice any more. Start drawing it and you will begin to notice details you can bring to your fantasy settings. Crumbling brickwork, the color of rust on a metal door, or the peculiar slope of the roof may all find their way into your work.

SKETCHBOOKS ARE SECRET

The first and most important rule of keeping a sketchbook is to remember that you are not working for show. If you are constantly concerned about producing a perfect drawing for others to see, your creative freedom will become limited and you will fail to tap into the infinite creative powers of your imagination. Sketchbooks are for ideas, not finished art, and it's important that you allow yourself to be free, make mistakes, and jot down any and all the ideas that come into your head.

◀▲▼RANDOM IDEAS

Don't be self-conscious. Jot down all your ideas no matter how silly they may seem at the time.

▲LIFE DRAWING: SPORTS

Drawing the world in which you live may not seem relevant to learning the art of fantasy combat, but any kind of life drawing can contribute to your development as an artist. For example, sketching people you see practicing tai chi in the park or basketball players muscling their way to the hoop, could help you draw better combat figures.

Inspiration and reference are two very different things. Inspiration is emotional. It is the thing that makes you want to make art—the books, paintings, films, games, stories, and life events that provoke the desire to create. It is the ideas and images that inflame your imagination and instill a passion in you that makes you want to be an artist. Reference is practical, and consists of the specific materials and sources that you must turn to to find out exactly how to turn your passion into a reality.

INSPIRATION AND REFERENCE

THE GOLDEN RULE

NEVER use your inspiration as reference. For example, you have seen a wonderful fantasy art battle painting that has filled you with the enthusiasm to go and create your own. So you indulge your passion and gather together a whole collection of similar fantasy art battle scenes and create your own version.

What you end up with is derivative, it is nothing that hasn't been done before and is quite possibly a poor copy of something that is already well-known to the public. Worse still, it is a dilution of the genre, creating an ever-decreasing pool of ideas and subjects with which the audience eventually becomes bored.

The solution is simple. Find inspiration wherever you can. Indulge yourself in the things you love and kindle the fire of your creative spirit. But when it comes to seeking reference for your work, you must go anywhere except the fantasy art genre.

INSPIRATION

Not sure where to start or what you want to paint next? Bored of drawing the same old scenes or characters? Go to sources of inspiration to get your creative juices going.

TEACHERS AND MENTORS

Throughout your life you will meet people who have incredible stories to tell and invaluable advice to share. Don't hesitate to seek out teachers and mentors in the most unlikely places and do your best to develop listening skills and the ability to learn from others.

ART, BOOKS, MOVIES, GAMES

It's not hard to find entertainment that inspires you in this age of immediate access. Keep lists in the back of your sketchbook of your top ten favorite films, books, comics, and games. Make this an ongoing project and keep revising and updating the list over the years. It's a good way of reminding yourself of the types of things that really move and inspire you.

COMBAT

If you want to draw combat, you have to be able to feel it. But rather than seeking out your local underground Fight Club, why not enroll in some classes such as fencing, archery, martial arts, or even tai chi. It will give you a great sense of movement, and it could open up a whole new world of possibilities that you may not have considered.

TRAVEL

Many artists and storytellers travel great distances to research their subjects. While this is not strictly necessary, direct experience leads to wisdom, and researching your material firsthand is all part of the joy of being an artist. But don't assume you have to travel to far-flung and exotic places—an inspirational journey can be as simple as going to see an exhibition in the next town.

EMOTIONAL TRIGGERS

At the center of every great piece of art is a human story. To give your work a true emotional charge, work from your own experience. Keep notes in your sketchbook of things that make you deliriously happy or sad, frustrate you, enrage you, or make you feel at one with the world. These will sometimes be things that seem mundane, but when you transfer them to an elaborate fantasy setting you may be amazed to see how well they work.

REFERENCE

Can't imagine your figure in three dimensions? Want to capture the perfect furious expression? Sources of reference can solve practical problems in your art.

ONLINE

The Internet is a seemingly infinite resource of imagery and ideas. For the purposes of combat art, it may be helpful to look at martial arts poses to really nail the angle and placement of limbs in your paintings.

PHOTOGRAPHY

Many artists take their own photographs for use as reference for their finished art. Props and costumes may be useful, but are not essential, and digital photography has made the process speedy and inexpensive. Such photography is particularly useful for combat art, as the poses can be complex and hard to draw without specialized reference.

MIRRORS

Most artists will also keep a small mirror near their drawing board so they can use themselves as a model for expressions, hand positions, and other details.

DOWNLOADS

There is a wealth of websites online from which CG artists can download wireframes of 3D figures and objects to use as the basis for their work. You can also find free sites that specialize in excellent photographs of textures, materials, and elements that you can use to skin your objects.

LIFE DRAWING

Although fantasy art emerges from the wellspring of the imagination, you can do no wrong by studying from life. Even the most advanced artists will return to life drawing classes throughout their lives to refresh their skills. If you don't wish to commit to classes, you can boost your drawing skills by sketching from life as you go along. Whether you

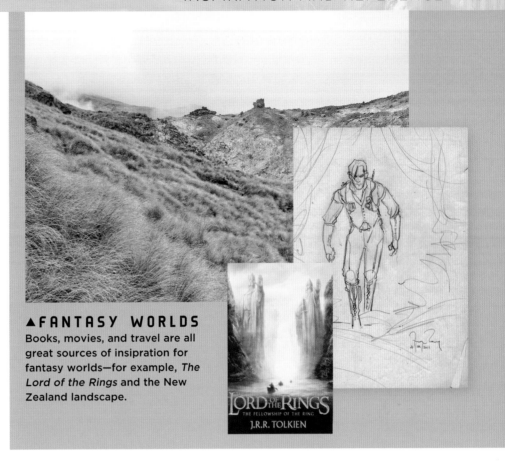

▲FANTASY WORLDS

Books, movies, and travel are all great sources of insipration for fantasy worlds—for example, *The Lord of the Rings* and the New Zealand landscape.

are doodling on the back of an envelope while sitting in a restaurant or hiking through the great outdoors in search of the ultimate sunset drawing, the world around us trains the eye and teaches us to look at things in a new way.

MUSEUMS AND LIBRARIES

Seeing great masterpieces or historical objects close up can tell you more than a photograph or print ever can. This is particularly true in the case of sculpture, which can be a primary resource in the genre of combat art.

▼COMBAT POSES

Go to a martial arts class for inspiration, then use pieces of sculpture in your local museum as reference to capture specific poses.

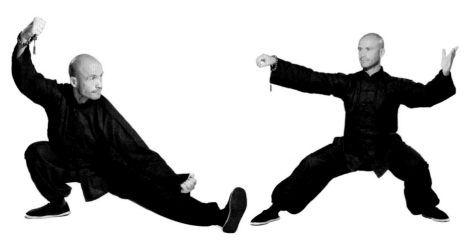

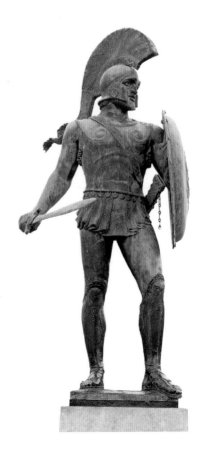

A basic understanding of the fundamentals of painting is essential. Even if you decide not to master the techniques of watercolors, oils, or acrylics, a study of painting will teach you invaluable skills and provide knowledge about color mixing, composition, and light and shadow that you will require when you move into other media.

PAINTING MEDIA

Watercolors are a great way to get started as a painter. They are quick, cheap, and flexible to use, but may cause frustration because they can be hard to control. Nevertheless, they are useful for getting your ideas down quickly and can be a joy to experiment with, watching colors and textures almost magically unfold.

"Who uses oils nowadays? I thought they were only for old dead guys from the Renaissance period!" Oils are great. They take forever to dry so you can push them around indefinitely—and that's the point; you can just keep working them. And what's more, oils will give you colors that you will find nowhere else so they will lend a unique style to your paintings.

You might be cautious about diving in and working with oil paint—but for many artists, once the smell of turpentine and linseed has gotten into their nostrils, they never look back. Imagine yourself as an alchemist from days gone by and get into exploring the wonderful world of potions and materials that is the domain of the master painter. There is a mystery and magic to working with all forms of paint, there is something eternal and timeless about it—and that, after all, is why you are here.

Acrylics use the same pigments for coloring as oil paints, but are bound by a synthetic resin and have the advantage of drying faster than oil paints. They are versatile and can be used in the same way as oils or they can be thinned with water or a thinning medium and then used like watercolors. They are available in two types: the cheaper "student" ranges and the more expensive "professional" ranges, which have a greater degree of color permanence.

◄ SKETCH IN PAINT
Even a beginner can get reasonable results with acrylics, so don't be afraid to dive in. This painting, by Finlay Cowan, was an acrylic "sketch," a study for a later, more refined work. Doing test paintings like this on cheap canvas or board is a good way to start, as you will find you feel less pressured to create a masterpiece. Just dive in, enjoy yourself, and don't be afraid to make mistakes.

WATERCOLOR PAPER

Watercolor paper comes in two types: cold pressed and hot pressed. The former allows sharper definition between colors than the latter, which allows colors to spread and absorb more. Heavier watercolor paper is more expensive but doesn't need to be stretched first. Use lighter watercolor paper for tests and experimentation, but stretch it first onto a board.

CANVAS AND PAINT BOARD

When using acrylics, gouache, or oils, you can begin with paint boards. These are an economic way to start out, but for the best results you will eventually want to use quality canvas stretched across a frame. It's cheaper to buy all the components separately and stretch your own canvases, but there are very good deals to be found for pre-stretched canvases, so do some research before you decide.

▲ BRUSHES

Your choice of brushes depends on the medium you are using, whether acrylic, oils, watercolor, or ink. Flat brushes are used for making bold brush strokes. Round brushes are used to cover large areas. Rigger brushes are used for painting long thin lines. Chinese brushes are great for creating interesting marks and patterns. Sable brushes are expensive but are wonderful to use. And nylon brushes are cheap, tough, and long-lasting.

There's no need to spend a fortune. You can begin with just three and build up a collection over time:
• A rigger brush for thin lines (also useful when using ink).
• A round brush for covering larger areas.
• A flat brush for making strong marks and patterns.

I would also recommend using a brush made from the tail of a unicorn, but they can be very hard to come by these days. Ask your local witch or shaman for advice.

THE ALCHEMIST'S LAB

Start off with some cheap acrylics or watercolors, but grab some oils, too. You could even try making your own out of mud, dust, toadflax, batwing, or goblins' tongues! Just get out there and experiment with whatever you can find or get your hands on. This is a pretty good rule if you are going to devote the rest of your life to being a starving artist.

You will need a palette (but any old plate will do), and you'll need water (or white spirit for oils) to clean your brushes. Sponges are useful for making textures, and so are plenty of rags and paper towels for cleaning up your mess. And it will get messy. That's all part of the joy of creation.

You will probably need a work desk and chair of some sort, but bear in mind that artists did manage to get by for about 50,000 years without the need for a state-of-the-art drawing board and an ergonomic office chair. We are talking fantasy combat art here—would Aragorn get sniffy about having the right table? No, he wouldn't, he'd just get to work and get the job done.

A lightbox is invaluable. This piece of kit is superb for doing multiple versions of an artwork and saving copies of the various stages of a job as you go along, or making tweaks and variations. You can make one yourself out of an old drawer with a fluorescent strip light and some Plexiglas over the top. Or you can buy them from art or graphic design material suppliers.

You don't need to have a fancy studio, but you will need plenty of peace and quiet to focus on your work. So if you can get only one thing, it's not expensive equipment you need, it's head space.

Watercolors are not normally associated with the execution of fantasy art, but you will find that most accomplished artists use them. Watercolors are quick to use and hard to control. This may be frustrating at the outset, but is liberating once you begin to see the amazing results that can be achieved.

WATERCOLOR TECHNIQUES

You may decide to use watercolors for doing quick studies before moving on to oils or acrylics for your final piece, and one of the many advantages of the medium is that the equipment required is very portable, which is useful when you are on the move.

Apart from their speed, the other great advantages of this medium are in the breathtaking range of colors that can be achieved (great for fantasy art) and the wide range of special effects that can be created, which we will look at here.

▶ IMPRESSING
When watercolors pool on the surface, you can use a tissue to draw away excess fluid. You can also dab wet paint with a tissue to create interesting textures.

BLOT EXCESS PAINT WITH A TISSUE, AND USE A DRY SPONGE OR CLOTH TO CREATE TEXTURES.

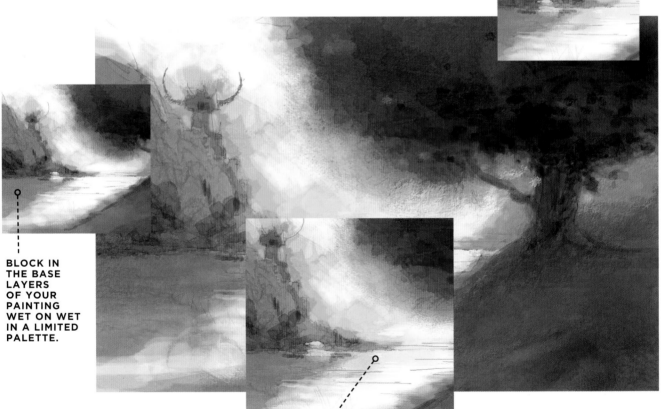

BLOCK IN THE BASE LAYERS OF YOUR PAINTING WET ON WET IN A LIMITED PALETTE.

LET DIFFERENT COLORS BLEED INTO EACH OTHER, CREATING AN ORGANIC BLEND.

▲ WET ON WET
The basic technique for using watercolors is to mix a little pigment with a lot of water and apply the paint to the paper quickly. You can also wash some clear water onto the paper first (with a clean brush) and then apply colors to the wet surface and watch them flow outward.

▲ BLEEDS
The great thing about watercolors is the dazzling explosion of color mixes that can result from applying a color next to another that is still wet and allowing them to bleed together.

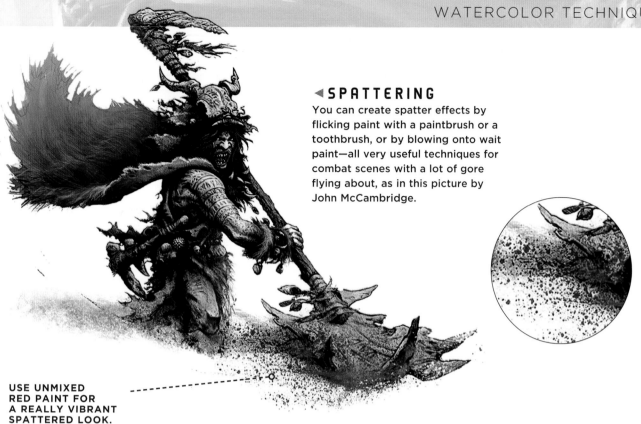

◄ SPATTERING

You can create spatter effects by flicking paint with a paintbrush or a toothbrush, or by blowing onto wait paint—all very useful techniques for combat scenes with a lot of gore flying about, as in this picture by John McCambridge.

USE UNMIXED RED PAINT FOR A REALLY VIBRANT SPATTERED LOOK.

ADD INK TO ADD DEPTH—HERE, IT REPRESENTS THE SHADED LEAVES.

ADD WATER TO CREATE A RICH, TEXTURED LANDSCAPE.

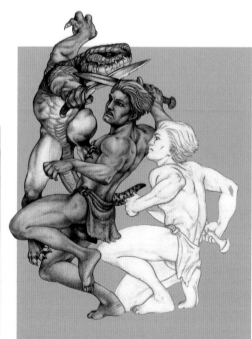

▲ ADDING INK

After laying down some colors, you can also add ink. This can be a risky business, as ink will cut through water very quickly, but it's great for adding hair and fire effects. Try laying down a wash of clear water first and then add a tiny drop of colored ink—just watch the great results as the ink blooms.

▲ ADDING WATER

After laying on color, you can drip water onto the paint surface with your brush to create blossoming effects and to control blending (insofar as you can control anything with watercolors). Such effects can be useful for rendering sea and sky.

▲ WATERCOLOR AND PENCIL

A pencil drawing can be enhanced with layers of pale watercolor, which won't obscure the pencil lines. You will find that it is quite easy to apply the paint to follow the pencil lines. You can also erase pencil lines even when they have been overpainted.

Acrylic is an important medium in its own right, and a range of techniques has been developed for both thick and thin applications.

ACRYLIC TECHNIQUES

Although flat and graded acrylic washes are made in exactly the same way as watercolor washes, and worked dark over light, they allow for more layers and more variations in the paint consistency than watercolor. Once the paint is dry, it is stable, so there is no danger that overpainted washes will disturb or move previous washes. Therefore, when using transparent methods, don't try to imitate watercolor since it is pointless. Instead, discover how to exploit the possibilities of acrylic for its own unique effects.

When used straight from the tube, acrylic paint has a buttery consistency. 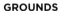 It can be moved and manipulated easily by brush or knife, and its character can be altered by the addition of various acrylic media. Paint of this consistency is perfect for direct approaches, with even relatively thick paint drying within the hour. Gel medium can be added to preserve brush and textural marks. Blending, scumbling, and broken-color techniques all work well with paint of this consistency. For impasto work, use tube acrylic paint extended with a heavy gel medium, or with a texture medium or paste. Alternatively, you can create your own texture medium using additives like clean sand or sawdust.

GROUNDS
Working directly onto white canvas or board can be difficult, so many artists apply a "ground" first. A flat ground can consist of transparent colors such as yellow ocher, burnt sienna, or neutral gray. A textured ground can be created by applying a dark color thinned with medium, and dabbing it with a cloth while it is still wet.

SHARP EDGES
The best way to ensure you achieve a sharp edge is to allow one area to dry before painting the adjacent area.

LIGHTENING A COLOR
If the paint is still wet, you can lift some of it off with a cloth to lighten it. If it's dry, you can try scraping it away with a palette knife, which will produce

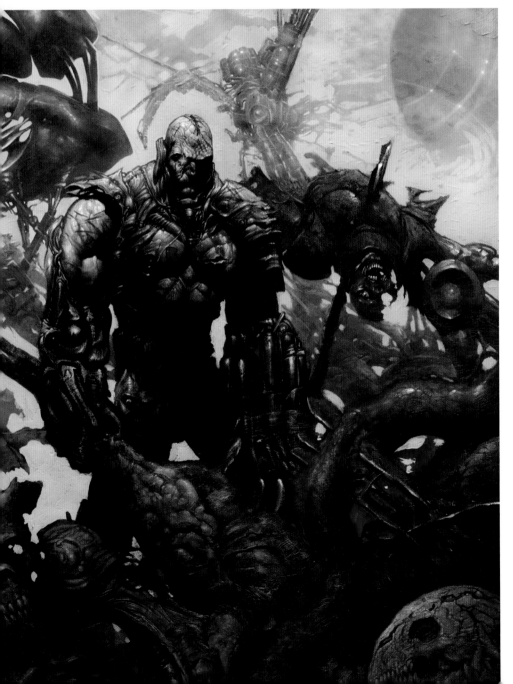

◄ **VERSATILITY**
It can take years of practice to master any medium, including acrylic. This painting by Liam Sharp shows a mastery of almost every painting technique and trick available to the artist from glazes, to sharp and soft edges, and a stunning ability to work with shadow and light, showing the skill of the artist and the versatility of the medium.

noticeable marks and textures which you can use to your advantage. You can then add lighter shades on top.

BRUSH MARKS

The best way to create visible brush marks is to use a stiff, dry brush. Linseed oil mixed into the paint will help the paint retain its shape as it goes onto the canvas. To avoid brush marks and achieve a smooth finish, mix artist's medium into the paint, and apply with a soft sable brush.

OVERWORKED AREAS

Some areas will undoubtedly become overworked as you practice and experiment, and your surface will end up with too much paint on certain areas. You can remove paint while it is still wet with an absorbent paper such as a paper towel.

BLOTTING

While you are immersed in the process of painting, you may find water collects on the stem of your brush and runs down onto your painting, causing blots and blotches. Be sure to keep an absorbent cloth or paper towel at hand to wipe your brushes regularly.

KEEPING PAINTS WORKABLE

Acrylics dry fast, so unless you are using a medium to keep them fluid, it is wise to squeeze only a tiny amount of paint from the tube onto your palette at a time. You may also wish to keep a small atomizer bottle handy and spray a fine mist of water over the paint from time to time.

OPAQUE AND TRANSPARENT

Acrylics are usually opaque unless you deliberately mix them with water or a medium to make them transparent. Adding a little titanium white can increase the opacity of any color.

BLENDING

Acrylics dry fast so you will need to work as quickly as possible, which can be a pressure at times. You can mix your paints with a medium to make them dry more slowly or, if you are working on paper, you can dampen it very slightly with a moist sponge, which will slow the drying process a little.

▼ GLAZES

Good transparent glazes are built up gradually in thin layers rather than in one heavy coat. Spread the paint out evenly across the surface, wait for it to dry, then add further layers as required.

LAYERS OF DIFFERENT COLORED GLAZED PAINT USED TO BUILD UP DEPTH.

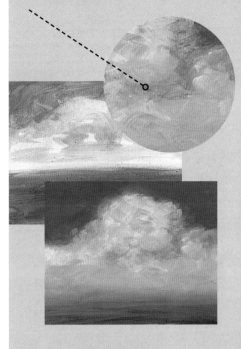

▼ SCUMBLING

Scumbling involves breaking up the original flat color by laying another, usually complementary, color on top to add depth and texture. Apply the new color over the first dry color, with a brush that is almost dry to enhance the texture. You can also apply the second color with a rag or cloth to create different textures.

WHITE PAINT SCUMBLED OVER THE ROCKS AND BACKGROUND TO REPRESENT FOAM.

▼ BROKEN EDGES

You are most likely to require broken edges when painting clouds or seas. You can achieve this effect by working wet paint into wet paint and allowing adjacent areas of wet paint to bleed into each other along the line where they meet.

WET WHITE PAINT WORKED INTO WET BLUE PAINT TO CREATE SOFT CLOUD EDGES.

▼ HARD EDGES

A method of creating straight hard edges is to use masking tape. Once the background layer of paint is completely dry, lay masking tape evenly over it and paint the new layer along the edge.

MASKING TAPE.

▼ PAINTED EDGE.

Imagine a ladder. You start at the bottom with the basics and work your way up. Sure, it's great to have a fast computer, big screen, and state-of-the-art software—but there's nothing wrong with a long journey. Frodo didn't demand a Lear Jet to get to Mordor—he walked.

DIGITAL MEDIA

So, let's begin at the bottom of the ladder. All you have is a pencil and some paper, but your imagination is infinite and the possibilities of what you can express with pencil and paper are limitless. After that, the limitations of technology kick in. Everything beyond the pencil and paper requires compromise, and you will inevitably experience some frustration. But don't ever fool yourself that the limits of technology are holding you back; your only limits are the frontiers of your own imagination and the desire to progress.

ENTER THE MACHINE
As a rule it's best to avoid secondhand computers and go for the newest, most powerful machine you can lay hands on. In terms of price and choice of software, PCs offer the greatest opportunities for the beginner. Apple Macintosh computers are luxury machines.

The difference is similar to that between buying a cheap Ford or a high-performance BMW. Apples are reliable, robust, and rarely break down, and that is what you pay for. So you can work toward a top-of-the-line machine, but in the meantime get started with whatever you can get, as long as you don't end up spending more time waiting for it to start up than actually doing any meaningful creative work.

DIGITAL ARTWORKING SOFTWARE
Certainly there are plenty of cheap products that you can download or find glued to the cover of a glossy magazine, but it's easy to spend the best part of your working life fruitlessly trying to wrangle a half decent result out of shoddy software. So when it comes down to software for digital painting, it starts and ends with two packages:

Adobe Photoshop and Corel Painter. Painter is the cheaper of the two and offers a stunning range of features for the artist. If you start with Painter, you may never need to touch Photoshop, which has a wider range of applications, depending on which industry you are aiming to work in.

3D SOFTWARE
If you want to get into gaming, you will find a staggering wealth of neat little packages available on the Internet, all of which have varying degrees of merit and will give you a taste for the genre—even Gary's Mod and Minecraft have evolved from little more than games to great platforms for training and experimentation, and computer games (including Halo's "forge" area) give beginners an opportunity to explore the medium.

APPLE MAC
The Apple Macintosh's fast processor, flat-screen monitor, and usability have made it a favorite for fantasy artists.

PAINTER
Painter is a highly specialized package designed to simulate natural media such as oil paint and watercolor.

PHOTOSHOP
Adobe Photoshop is generally regarded as the best art-generation and image-editing package.

LIGHTWAVE
LightWave 3D is used for rendering animated and static 3D images.

▶ HYPER REALISM

Hyper-realistic digital artworks such as this are usually associated with high-end software such as Lightwave or Studio Max. This amazing artwork by Joe Peterson was actually produced in Photoshop which, although a highly advanced program, is surprisingly accessible and benefits from its integration with the Adobe Creative Suite, which has a host of useful tools for artists, designers, and film makers.

If you find that this is your thing, you may then wish to look at Bryce, Poseur, and 3D Studio Max to get more serious and start developing standard skills and experience.

Finally, way up at the top of the line, you will find Lightwave, which is remarkably well-priced considering you can use it to singlehandedly make a cinema-quality movie, but also requires "a brain the size of a planet" to learn it. Besides, there's bound to be some eight-year-old kid somewhere on YouTube who's posting tutorials on it, just to prove me wrong.

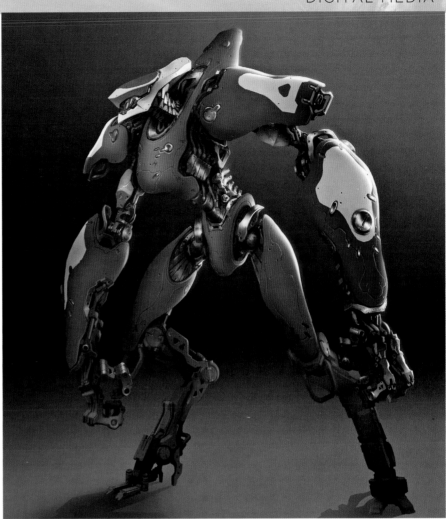

◀ PAINTERLY

Not all digital artwork is hyper realistic and glossy. In the past few years the tools available in Photoshop and Painter have made it possible to not only achieve very painterly results, but also work in a very similar way to painters. Responsive brushes and a range of digital canvas and paper textures have made the whole process of digital painting more interesting for artists who prefer to work in traditional media. Jonas Springborg used Photoshop to create this image.

In the ancient times of digital art (as long as ten years ago!) digital painting required a different set of skills to those used in traditional painting in order to achieve the same effects. Things have changed, and with the development of responsive brushes, enhanced software, and modern drawing tablets, the techniques required for digital and traditional painting have become very similar.

DIGITAL TECHNIQUES

Artists who have trained with acrylics and brushes can make the transition to digital media quite easily. This means that the processes and skills, both creative and practical, acquired in the age-old practices of looking, drawing, mixing, and painting are still invaluable even to those artists who choose to work entirely in the digital world. So, whether you are working digitally or traditionally, you can't lose!

◄ LAYERS

Most digital software uses a system of layers, allowing the artist to work on a series of virtual separate, transparent sheets "laid over" each other. This makes the whole process flexible, allowing you to discard unwanted elements and experiment to your heart's content.

▶ SAMPLING

You can add a rich tapestry of tone, texture, and detail to your digital paintings by sampling textures from photos and other illustrations. The trick with sampling is to work heavily into the source material by changing the colors, blurring, smudging, and using the clone tool to change the overall pattern or texture. If you don't, the result tends to look clumsy, as though it doesn't belong there. With care and attention, you can use a photo of clouds to create fire or reflections, you can use the skin of a crocodile to add texture to armor. Similarly, you can create your own texture libraries from photos you have taken yourself.

▼ SMUDGE

The smudge tool is excellent for creating a painterly effect on your artworks. You can block in areas of color with hard edges, then blend them together with the smudge tool as you would do when mixing colors on the canvas in wet-on-wet painting (see pages 18–19 and 31).

Again, the trick is to use the tool subtly and carefully to develop the "sfumato" effect described on page 34. The smudge tool is also an excellent way of developing your own texture libraries. Take photos and painstakingly go over them with the tool to create your own textures.

◀ BLENDING

Blending is useful in the later stages of a digital painting. You may find yourself with a great many layers; some may look painterly, others may have defined lines, and others still may have sampled textures such as clouds or fire. It doesn't seem to hang together, but don't despair! You can save a copy of the original layered file and work on a duplicate that has all the layers flattened into one. You can then go over the whole thing again with the smudge, dodge and burn tools, and other filters and effects to bring the whole image together.

▶ DODGE AND BURN

The dodge and burn tools are used to create highlights and shadows. They can be used to give volume and the impression of form to a painting. Inexperienced artists tend to make the mistake of being heavy-handed with the tools. It's best to set the tolerance as low as 3–4 percent and build up the shadows or highlights with a succession of light strokes, much as you would do when painting.

There are general working practices and ways of putting together combat artworks that will help you become a better artist and apply to all media. These core techniques are discussed here.

CORE TECHNIQUES

DRAW BIG AND GET PHYSICAL

Drawing and painting is as physical as it is cerebral. There is a kind of path from the idea in our heads, through the emotions in our heart, and along the arm to the pencil at the end of it—from the idea, to the feeling, to the physical act. You can see an enormous difference between the big art created by artists who stand up and stand back from their work and those who work hunched over, their elbows cramped into their sides, and their noses an inch from the canvas.

Digital art is no exception. With large-format tablets and mobile screens, digital artists are now free to be more physically expressive with their work. This is especially the case in the genre of combat art. This focuses on bodies in motion and requires the artist to have a keen sense of physicality in order to evoke the power and beauty of figures in action.

IN AND OUT OF YOUR COMFORT ZONE

Some artists love detailed line drawings with little shadow or tone, some artists relish lush colors and sweeping statements, some work slowly, some work fast. There is no right way of doing things. Indulge yourself in what you feel comfortable with, immerse yourself in your chosen technique and master it. But when you feel that your work is getting tired or repetitive, try a new direction. This happens with almost all artists, who are as a breed by nature obsessive, and strive to achieve mastery of a particular medium or technique. In doing so it's natural to reach a plateau—when that happens, start to look toward new horizons. The process of struggling to get a result from a new approach is as much part of being an artist as sitting back and enjoying the satisfaction of a finished piece.

WORKING IN ATTACKS

Imagine the process of creating a finished image as a series of attacks on an idea. To begin with, the idea is vague and nebulous, wreathed in shadows and smoke, but each time you attack, it becomes clearer as you cut away at the various options and obstacles that may be obscuring your final vision.

As you search for reference and inspiration, you can jot down ideas in your sketchbooks. It's best to do this as you go along, always making the effort to record what you see and think, even in the most primitive doodles. You will later refine those ideas and concentrate on designing your characters, costumes, and environments.

As you go along, the all-important dramatic and emotional aspects that lend the image its meaning will become clearer. Each time you open your books and tackle the subject, you will find that the concept crystallizes a little more until it sparkles with life. Finally you will come to the execution of the final art. Use the same approach and work in a series of sweeping actions beginning with thumbnails, rough layouts, and final pencil drawings, and then apply color and detail. Be conscious of these "sweeps" and only move on when you are satisfied you have solved the problems posed at each stage.

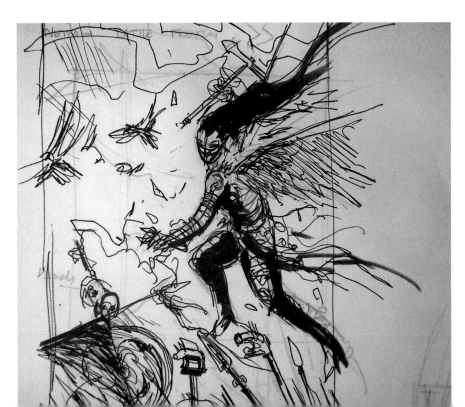

◄ GET IT ALL DOWN
Fully formed images will not come to you right away. You will need to work away at ideas in a number of attacks over a period of time. Your sketchbook should not leave your side during this time, so that you can draw and write down developments as they come to you.

COMBAT ESSENTIALS

The art of combat is essentially an art of movement and weaponry. You will need to master a specific form of anatomy drawing and develop an intimate knowledge of the relevant weapons and armor technologies. These are the two primary elements of combat art that you will then set against two backdrops: the physical backdrop of the environment and the emotional backdrop, which provides the drama of your image. These four elements will all push and pull against each other to create the overall dynamic of your artworks.

WHAT'S THE STORY ?

Before you even begin to start creating your artwork, it is essential to develop a single strong idea for any image you want to produce. The power of the whole image hangs on this central theme; it is the core of your artwork, and without careful consideration of this central "concept," your work is likely to end up as a copy of someone else's idea.

The simplest technique for developing a concept for an artwork is to tell yourself the story leading up to the moment you will be depicting. This is known in screenwriting as the "backstory" and sets the scene for the viewer.

You may wish to use a classic scene from mythology or history and add your own unique twist to it. Alternatively, you may wish to pay tribute to a contemporary fantasy book; it is your choice. The one thing you shouldn't do, however, is copy a contemporary fantasy artwork.

▼ **IN PRACTICE**

Develop some ideas for a combat scene by addressing each of the four combat essentials in turn: anatomy and movement, weapons and armor, physical environment, and dramatic situation. As you focus on each one, you will soon see how they influence each other and push you to come up with interesting solutions.

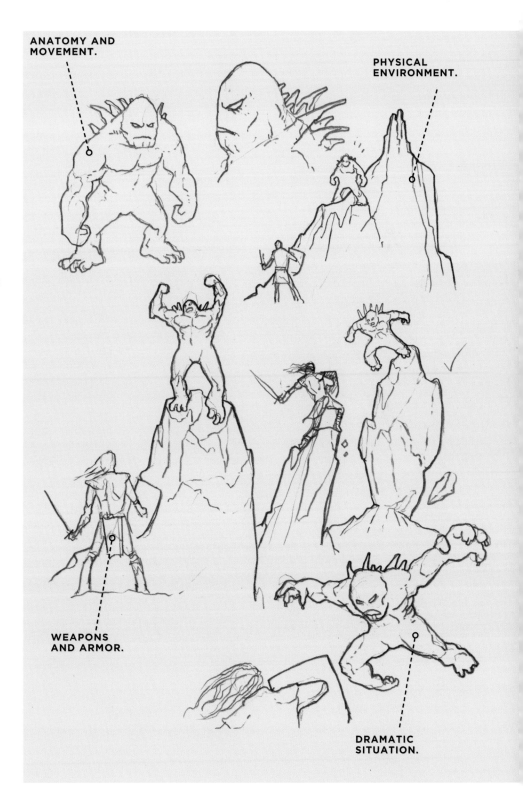

ANATOMY AND MOVEMENT.

PHYSICAL ENVIRONMENT.

WEAPONS AND ARMOR.

DRAMATIC SITUATION.

Tonal values are used to create depth in an artwork. The balance of tonal values in your artwork will create a focal point for your painting. The human eye is naturally drawn to light areas next to dark areas in a painting, and it is the resulting contrast that creates the focus of interest.

TONAL VALUES

The use of tonal values is important, because areas of dark and light create the illusion of three dimensions in your artwork. The use of a range of different tonal values, moving from dark to light and vice versa, creates the illusion of depth.

Tonal values may be hard to understand at first, especially when working with color, but all colors have their own position in the spectrum, which will cause them to emerge or recede from the canvas depending on how they are used. To start to understand tone, begin by working with a single color—or just black and white.

The best way to understand the importance of tonal values in your artwork is to look at black and white

▲ TONAL PALETTE

Last Stand by Raymond Minnaar is a good example of the use of tonal values alone to provide the entire color range of the artwork. The artist has stuck rigidly to a narrow range of colors—mostly gray with a touch of red on the flag and some pale greens in the background. He has used the full spectrum of tones from dark to light to create depth and space in the composition.

◄ TONAL VALUES

This chart shows how we can use tonal values in color in the same way that we use them in a single-color image or in black and white. If your painting used a line of horizontal colors from this chart they would change in hue but not much in tone. The result would be an image with no tonal range. The trick is to use a range of colors chosen vertically from the chart, moving from dark to light. For shadow areas you would use colors from the bottom of the chart, choosing progressively lighter shades from those further up the chart as the areas of shadow move from dark to light.

▼USING TONE

Begin by looking at different ways of lighting simple objects. Make a simple line drawing in pencil with no shadow or tone at all.

1 Make two copies of your drawing. Either scan it and print it out or use a lightbox to trace it. If you scan and print, you could try printing onto printer-friendly watercolor paper so you can paint. But for now it would be easier to work in pencil.

drawings or photographs. You will soon see that some artworks have a narrow range of tone—these may look quite flat. When the contrast between the black and white areas is increased, you will see that the image conveys a stronger impression of light flooding into the scene.

So what use is a range of tonal values? Light and dark tones create depth and light in an image. Try scanning a finished drawing and converting the image to grayscale in your photo-editing software. Ask yourself, is there a good contrast or do all the tones look the same? If the tones look the same and the result is quite flat, then you haven't made the best use of tonal values in the artwork.

2 On one version add really dark shadows and strong light. Here you can see that the light source appears to be to the side.

3 Make another version in which the light source appears to come from above. This has a noticeably different effect on the object, and shows just how important and useful the careful execution of tonal values can be.

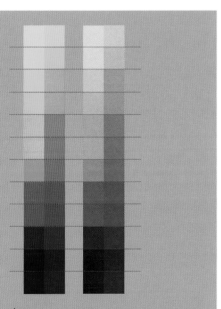

▲ When different values of one color are turned into black and white, it is possible to clearly see the difference between the dark and light values.

4 Make a third version in which there is a gradation of tonal values. The image has no stark shadows or strong light, but employs a range of tones to move from dark to light. The tonal values continue to create the illusion of 3D.

Colors are the building blocks of your painting, so it is a good idea to know something about the fundamentals of what color is and how it works. Every color has a personality and a way of behaving, and the more you know about this, the better.

COLOR THEORY

PRIMARY COLORS

A primary color is a color that cannot be made by mixing other colors together. Red, green, and blue are all primary colors. In theory, primary colors can be mixed together in one combination or another to mix all other colors. In practice, these rules are not strictly true, but are used as a general guideline for all color mixing theory.

SECONDARY AND TERTIARY COLORS

Secondary colors are made by mixing two primary colors. These are green, orange, and violet.

Tertiary colors are made by mixing one primary color and one secondary color, giving a range of six colors.

These are:

Red + orange
Red + violet
Yellow + green
Yellow + orange
Blue + green
Blue + violet

Every color has three sides to its personality: hue, value, and chroma. In order to accurately match colors on your palette, you need to consider all of these.

HUE

Hue at its simplest is the actual color of a pigment (or object). When looking at the tubes of paint produced by a manufacturer, the term hue is used to suggest that the paint is not directly from an original pigment but from a synthetic version of that pigment, which can be a little confusing. But, whatever the origin, it is the specific hue that the artist first thinks of when reaching for the palette to begin mixing.

VALUE

Value is simply a measure of how light or dark a color is. It sounds simple but it has to be considered without reference

to the actual color (or hue). Sometimes you need to compare two colors such as a red or a blue, and it can be very hard to tell which is the darkest.

This is important when you want to include several different colors in an area of a painting, but their values must all be the same so that the impression of light and shadow across the whole painting is consistent.

The appearance of a color value—its lightness or darkness—can also be affected by what is going on around it. Nearby colors will cause it to merge or recede, depending on the balance of values they have. This is important when it comes to obtaining the right three-dimensional effect.

Warm colors are often useful for the central focus of the image. They sing out loud and clear.

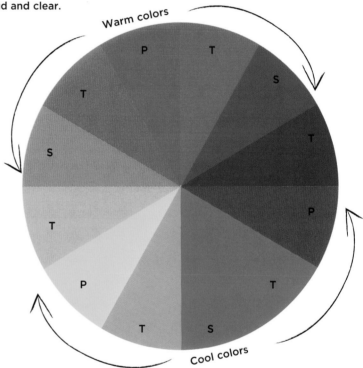

Cool colors are recessive. Use these for background washes or in conjunction with a warm color for a stark contrast.

CHROMA

Chroma, also known as saturation, refers to how intense a color is. Imagine a pure, solid color compared with a color diluted with white or black or thinned with a glaze or medium. Variations in chroma are created by adding amounts of a neutral gray of the same value as that of the color you are working with.

Chroma and value are easily confused, but with chroma you must consider how intense the color is, while with value you must think about how dark or light it is.

Colors produced by mixing paints are governed by the CMYK system, while those produced by mixing with light (as you would working digitally) use the RGB system. The two systems have very different results: mixing red and green paints will produce brown, while mixing red and green light will give you yellow.

COLOR MIXING

CMYK stands for cyan, magenta, yellow, and black (the K is used instead of B so nobody thinks it's B for brown or blue). RGB stands for red, green, and blue. Television monitors and computer screens rely on tiny dots of these three colors to make up all the colors needed. CMYK is the system used if the final product is a physical painting, while RGB is used when the final result is digital, such as computer game art, movies, and animation.

DARK TO LIGHT
It takes a lot of a light color to lighten a dark one, but it only takes a tiny amount of a dark color to darken a light one. So always add blue to white to darken it rather than trying to lighten the blue by adding white.

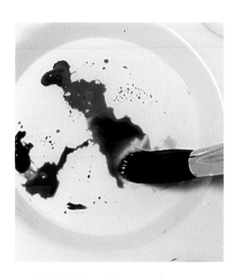

▲ MIXING ON A PALETTE
There are two distinct methods of mixing on a palette. The first is to mix the colors completely together on the palette so you have a ready supply of one consistent tone to use in your painting. The second method is to create an incomplete mix of colors on the palette, which results in variations in color. As you paint with an incomplete mix, the colors continue to mix on the canvas, which can result in some superb effects.

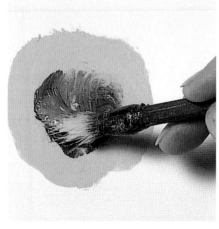

▲ MIXING ON CANVAS
Instead of mixing your colors on the palette before applying them to the surface, you can mix them on the canvas as you paint. You will gradually learn from experience exactly how much paint to apply. It's risky and can create a mess on your canvas, but it can result in much greater spontaneity, and sometimes produces some amazing effects.

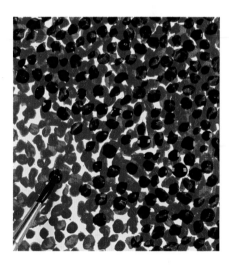

▲ OPTICAL MIXING
Optical mixing of color is a process that takes place in your eye, not on the canvas. If you have very small areas of different colors next to one another, when seen from a distance, they appear to combine. When you look close up, you see that they are separate from each other. The colors aren't blended together and so it may take more time to work in this method, but when color is applied in this way, it produces the effect on our brains of making the color appear to move.

We've seen how choosing the correct range of colors for any element of your painting is very important. Specific details such as armor, skin, and hair all have their own tips and tricks to make them work well—and these are often not what you may think.

▶ ARMOR

Needless to say, if you are painting combat you will need to depict armor and there are many techniques for doing this.

Use a dry brush to apply metallic colors such as silver, copper, or gold directly onto black. This is a great way of leaving strong shadows and giving the effect of highlights on armor.Some artists use a paint called Tamyikas Smoke, which can be found in craft stores, and is used by modelmakers to give a dirty look to their armor. It is very dark so work it into the shadow areas and dip your brush in water first to dilute it.

Try painting chain mail in black first, then carefully go over it with silver to provide shine and body.

For a bronze look, first undercoat the area in yellow or brown, and then add details with bronze metallic paint or, for a more subdued effect, use brown or chestnut ink.

Some metal color mixes are suggested, right.

▼ COLORS FOR A BRONZE SWORD HILT

This has been done in acrylic, used thinly in "watercolor mode," but a similar effect can be achieved with watercolor, using a little acrylic or gouache white for the highlights.

1 Wash greens, lilacs, blues, and reds over shaded areas, and allow to dry.
2 Wash yellows loosely over the lighter parts of the metal, allowing the color to overlap the shaded areas in places.
3 Leave to dry, then put in the darkest shadow details with mixes of purple and blue to make maroon hues.
4 Add red for the shadow areas along the edges, which reflect the rich metal color.
5 Finally, add highlights with white, softening the edges with a damp brush as needed.

GRAY/SILVER METAL

Phthalo blue with a touch of both green-gold and magenta

Prussian blue with a touch of green-gold and magenta

BRASS AND GOLD

Permanent yellow with a little green-gold and bright red. Yellow alone for highlights

Green-gold with a touch of bright red and Prussian blue

HAIR AND FUR

For hair or fur to look believable it should follow the shape of the head (or body) and appear to move with the figure or in response to the wind and rain. Work wet on wet and paint in the direction in which the hair flows from the head. Hair does not usually appear as individual strands but as a mass of color with many variations of light and tone in it. Raw umber can be used instead of burnt umber, which can be too dark, and a tiny amount of red can be added. The effect is invisible but lifts the whole color nicely.

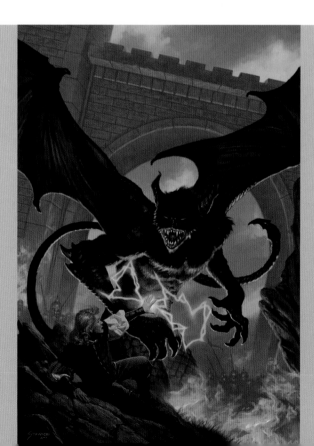

◀ MAN AND BEAST

Sooner or later you are going to have to tackle fur and hair, whether you like the idea or not. Whether it's the long flowing silky blonde locks of the questing hero or the coarse and filthy matted fur of the flying bat beast in the painting shown here by Matt Stawicki, hair and fur are a fantasy essential.

▼ SKIN

The precise colors you use for skin tones will vary enormously, of course, depending on the character you are painting. Paints sold as "flesh" or "skin" colors are rarely adequate for the variety of skin tones you will require, and invariably you will need to mix your own colors.

Some skin-tone mixes are suggested, below, but every artist develops their own preferences, so this list is not definitive. You may wish to experiment with a wide range of colors such as deep purples, golden ochers, and even various greens.

FIXING MISTAKES

The first trick when correcting mistakes is to try to remove some of the paint while it is still wet. You can use cloths or a palette knife for this. Smooth down the remaining paint, then leave it to dry. After it has dried you may still see unwanted texture in the remaining paint, so you can try sanding it down with some fine sandpaper, brushing away any dust that has accumulated. Finally, paint over the area with titanium white and start again. Don't apply the paint too thickly, as this will result in unwanted shadows and texture. Work in thin layers until you are satisfied with the result.

	WATERCOLOR		**ACRYLIC**	
CAUCASIAN				
	Small amount of permanent red with touches of green-gold, crimson, and Prussian blue	Permanent red with touches of permanent yellow and Prussian blue	Brilliant red with a touch of light green	Yellow ocher with a touch of brilliant red
AFRO-CARIBBEAN				
	Permanent red and phthalo blue	Permanent red with touches of Prussian blue and green-gold	Blue lake and brilliant red	Yellow ocher, blue lake, and brilliant red
ASIAN				
	Green-gold and permanent red	Green gold and magenta	Yellow ocher with touches of light green and blue lake	Yellow ocher and a touch of blue lake

Once you understand the ways that color works you can start using it in exciting ways. Leonardo da Vinci, Rembrandt, and other great Old Masters developed techniques that can be used to great effect in fantasy art—learn from the best by studying their work and using it to inspire your own paintings.

USING COLOR AND TONE

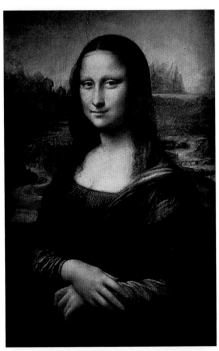

SFUMATO

Sfumato is a style of painting used by the Old Masters and notably Leonardo da Vinci, who was rather good at it. It is a subtle gradation of tone used to obscure sharp edges and allow the various elements of a painting to sit nicely with each other, giving the impression of real life. Leonardo was actually considered to be the inventor of this method, which blurs outlines and merges colors together to replicate how we see objects in real life—that is, a little fuzzy around the edges.

Look at the Mona Lisa (you might have heard of it, it's quite well known). Leonardo matched all the mid-tones such as the blues, greens, and earth colors so they had similar degrees of chroma and avoided bright colors, which would have broken up the consistency of the painting as a whole. These chroma-balanced mid-tones give a subdued quality to the painting.

He then took this further. As you move away from the figure of the Mona Lisa herself, all the other areas of the painting blend into shadow with an almost monochromatic range of color. This method of using a narrow range of chroma and hue is widely used by game designers and film-makers to give a stylish mood to their work.

CHIAROSCURO

Chiaroscuro is in some ways the opposite of sfumato, in that it uses an almost heavy-handed approach to dark and light, and uses stark contrasts to its advantage. Rembrandt was famous for his use of this technique; his figures are often brightly illuminated, while the backgrounds are in extreme shadow.

Chiaroscuro literally means "light and dark," and is very popular with artists such as Frank Miller whose films *300*, *The Spirit*, and *Sin City* all used this technique to great effect.

In painting, the effect is created using a succession of glazes of transparent brown or burnt umber for a warm effect. The main elements of the painting, such as the hands or the faces, are given plenty of highlights, but you will nevertheless need to warm up your colors with a little red to make up for the cooling effects of the surrounding dark areas. Other areas that are less important, such as, perhaps, the clothes, can then be painted in dark colors, and allowed to merge into the shadow.

For a Rembrandt-style chiaroscuro effect try using yellow ocher, burnt sienna, burnt umber, and cadmium red, as well as white and black. Also, it's worth noting that Rembrandt always worked on colored grounds, never white.

◀▲ OLD MASTERS

Mona Lisa by Leonardo da Vinci uses sfumato (top left) and *Self Portrait* by Rembrandt uses chiaroscuro (bottom left).

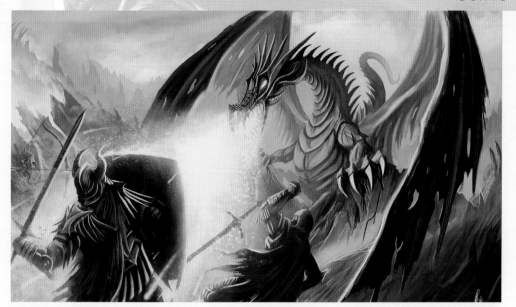

◄CHIAROSCURO

This painting by Raymond Minaar, *Inferno*, is a great example of chiaroscuro at work. The artist has stuck to a classic palette of burnt umber and yellow and created stark contrasts between dark and light, which is the hallmark of chiaroscuro. The result is a highly atmospheric effect achieved by using a very narrow range of colors and a strong sense of lighting.

◄SFUMATO

Daniel Ljunggren has used the sfumato technique to great effect in this painting. He has matched all the mid tones, using blues and grays, with similar degrees of chroma, and has only used bright colors for a few highlights to give form to the various elements and draw the eye in. The balanced tones give a subdued quality to the painting, which is especially relevant to an artwork with such a dark subject matter.

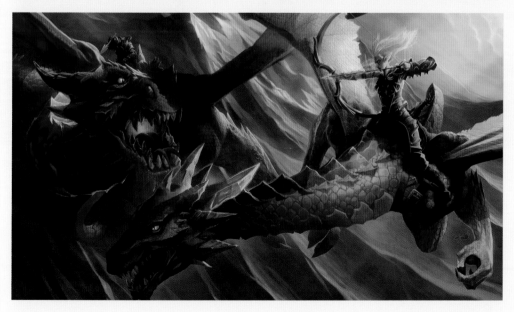

◄HUE AND VALUE

In this painting Anton Gustilo has chosen colors with closely matching hues—the reds and oranges of the dragons with the greens and yellows of the landscape. The only exception is the flashes of blue from the dragon rider's weapon, which draw the eye to the action. Gustilo has then used the values of each color to create depth in the painting.

FIGURE BASICS

2

"I exhort you also to take part in the great combat, which is the combat of life, and greater than every other earthly combat."

Plato (427–347 B.C.)

Artists are renowned for being a bit, well... different.
Modern humans find it very hard to stand and wait—as soon
a person has to stand still for more than ten seconds it's out
with the smartphone and a faked air of being engrossed in
some very important text message. Any true artist, on the
other hand, will not be quite so self-conscious.

BASIC ANATOMY

They will stand enraptured by clouds above a skyscraper,
by the play of light on a billboard, or the swish of fabric
on a woman's dress.

Artists need to learn to look before they draw. Be prepared
to stare endlessly, to look deeply into things. Drink the world
in; the harder and longer you look, the more interesting it
becomes.

This attitude of looking intently also applies to the artist
when they return to their studio or desk. Even staring at that
blank sheet of paper in front of you can be useful. But more
than any other thing, the observation of human anatomy is
the all-important activity for the fantasy combat artist. It is
only with dedicated and prolonged observation of the
richness and diversity of the human body that you will
capture the essence of this most challenging of subjects.

No matter how many excellent books you gather on
the subject, there is simply no substitute for drawing from
life. You may want to enroll in a class, but you can sketch
anywhere and it is advisable to do so! It's not easy. It takes
quite a bit of confidence to pick up your pencil in public, as
it may attract attention. What's more, your subjects may not
always wish to be sketched—but you can start at home. The
prospect of drawing your brother or sister hunched over their
games console may not be very appealing when your mind
is bursting with ideas for epic fantasy battle scenes, but you
will find that any form of life drawing is invaluable to your
development, no matter how far removed it seems from
your artistic dreams.

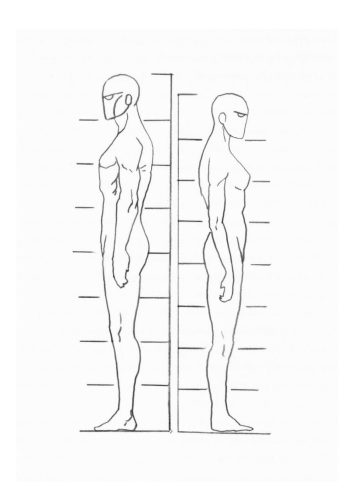

PHOTOS

It will be apparent in your work if you use references
taken from other illustrations or photographs, but you
have to start somewhere. Using photographic reference
is fine, as long as you don't ignore the need to draw
from life and build your own knowledge of anatomy.

▲ BASIC HUMAN PROPORTIONS

Leonardo da Vinci used the human head as a unit of size
for judging the proportions of the bodies in his art. In this
illustration you will see that the body is roughly equal to
seven heads in height (sometimes eight). Of course, with
fantasy art, such rules are often broken, but it is useful to
draw humans as they really are—except for hobbits, of
course—and dwarves, elves, and ogres... pretty much
everything, really!

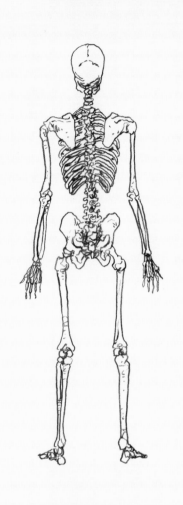

◄ THE SKELETON

Imagine the skeleton as the framework on which your character is built, something like the chassis of a vehicle. You don't need to be an expert, but having a reasonable understanding of the bones of the body is essential for "hanging" the musculature of your characters on. Besides, skeletons often come in useful in the world of fantasy combat. Let's face it, there are going to be a lot of skeletons lying around... and quite a few walking around, too.

► BASIC BLOCKS

Many artists begin by building their characters on blocks, much like the wooden figures you can buy for posing figures. This is a good way to start and it will be good practice with basic anatomical structure.

◄ WIRE FRAMES

Building your character out of blocks will only take you so far. The human body is flexible and organic, so try using fluid spiraling pencil lines to create a "wire frame" effect.

► FANTASY MUSCULATURE

Fantasy musculature requires the same muscle groups as those for standard life drawing and the interaction between the muscles is the same, but it is exaggerated— everything in fantasy is supersized (except, of course, when it's supershrunk, in the case of hobbits, dwarves, and sprites).

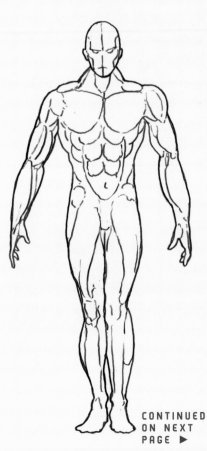

CONTINUED ON NEXT PAGE ►

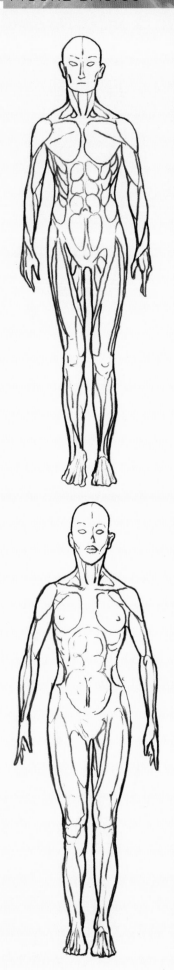

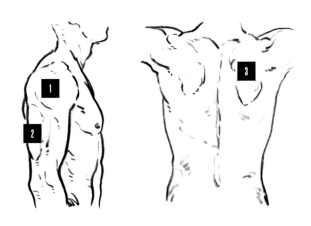

◀ **BASIC MUSCULATURE**

The muscles largely define what a human body looks like. It is useful to study the basic muscle groups to get a sense of how they work together. As a general rule, long muscles are found on the limbs and broad muscles move the trunk. Begin by copying or tracing this image to get started.

◀ **FEMALE MUSCULATURE**

Female figures require the same muscle groups as male figures, but there will be a few variations: The waist should be slimmer and the hips proportionally wider; the neck should be a little longer; and, as a general rule, the fingers, hands, and limbs are smoother and finer. Unless, of course, you are drawing a gruesome witch—then you'll want to make her look like a twisted old tree trunk!

(1) Deltoid
(2) Triceps brachii
(3) Trapezius
(4) Biceps brachii

(5) Rectus abdominus
(6) Pectoralis major
(7) Latissimus dorsi
(8) External oblique

▲ **LOOK AND LEARN**

Musculature can take a long time to master, so be patient and don't despair. The more you study from life, the more you will be able to identify and accurately reproduce different muscle groups. Remember, fantasy musculature can stray a long way from reality, so once you have figured out the basics you can enjoy yourself by adding muscles where there aren't any. Secondly, you can develop your own highly stylized way of drawing muscles, as you can see in these sketchbook drawings.

Fantasy combat characters lead hard, demanding lives; always on the move and always up against some new enemy guaranteed to be more fearsome than the last. Well, life is full of challenges, especially if your goal is to defeat a dragon that's been ravaging the landscape and stealing all your fair maidens, so fantasy heroes and heroines are always on the move.

FIGURE IN ACTION

Needless to say, it's essential that you learn how to draw figures in action. I've never seen Legolas waiting at a bus stop, so there is only so much real life observation that you can use. But you can always ask permission to sketch at martial arts schools, or at sports and gymnastic events to practice drawing figures in combat-type poses. A simple technique is to view the body as a set of simple building blocks. Once you have broken it down into these basic shapes you will find it easier to understand how the body twists and turns, and how it can be shown in perspective.

BASIC FIGURE DRAWING

Drawing stick figures and then fleshing them out is a good way to start drawing the figure in complex combat poses.

1 Lay down some perspective lines first to create a space for your character to stand in. Begin by drawing a loose stick shape, which will provide a guide for the length of the legs, body, and arms. Keep it very rough and add as many lines as you want in order to define the right proportions.

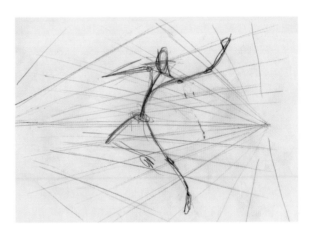

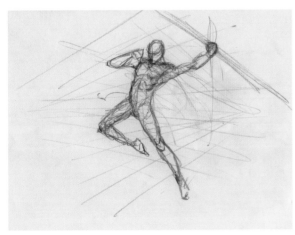

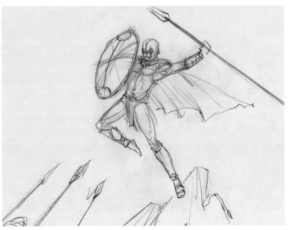

2 Start to flesh out the figure. Use flowing, curvy lines. When drawing figures in action, try to breathe as much energy as possible into them with your pencil, brush, or digital stylus strokes. You may find you need to adjust the pose of your figure from the original stick figure you drew. This is, of course, where you will add the detailed musculature.

3 Next, add clothes or armor. It is not always necessary to draw the musculature of a figure before adding clothes, but it helps when you are developing your skills and many accomplished artists do it as a matter of course. Obviously, if your character is wearing baggy clothes you will no longer see the detail of the muscles you have drawn, but doing it helps give your figures solidity.

CONTINUED ON NEXT PAGE ▶

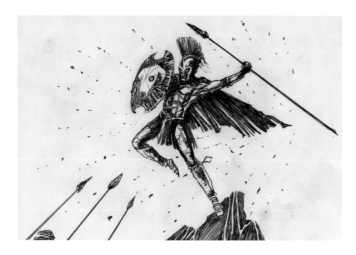

4 Finally, add fine details and shadows. It is entirely feasible to begin your drawing with large areas of shadow—there is no strict order in which you create an artwork—but you will also see from this drawing that the basic stick figure and musculature stages of the process have had a direct effect on the final outcome, including the way the clothes hang on the body and where the shadows fall.

FORESHORTENING

Foreshortening is the term used when things look smaller as they get further away from us—the effect of perspective. The ability to draw foreshortened figures is essential in combat art, as it helps to convey action. Drawing foreshortened figures also tends to be quite difficult, so here is an exercise to get you started.

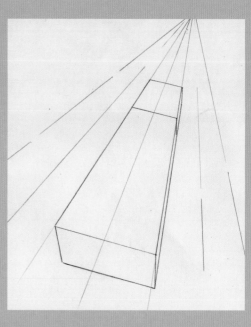

1 It's easier to see how an object is foreshortened when the shape is simple, such as a rectangular block. So begin with perspective lines and a basic shape.

5 The final sketch was scanned and reduced to a stark black and white in Photoshop to create an image inspired by the work of Frank Miller in his graphic novel *300*.

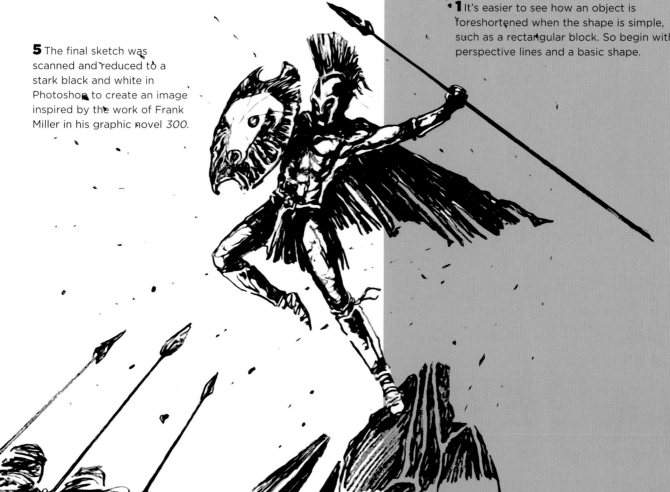

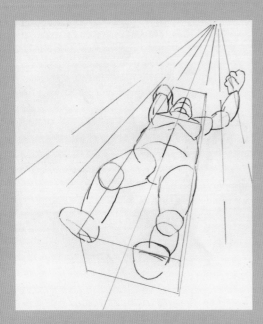

2 From this example, you can see how a figure can be constructed within the perspective using basic volumes. You can see how the figure appears to become smaller as it recedes from our viewpoint.

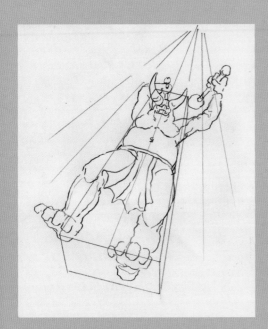

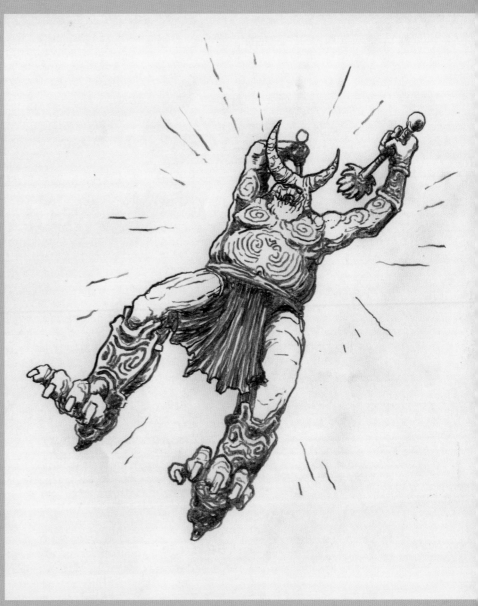

3 At this stage the figure looks very stiff, but it is only meant to be a guide for the real drawing that now takes place. The accurate structure that you have created will allow you more freedom to flesh out the actual figure.

4 In the final drawing, with the perspective lines and blocks removed, you can see how the figure appears foreshortened and has the necessary dynamic tension of a figure in action.

It is impossible to define a specific male body shape when it comes to fantasy art. You might choose from the typical marauding Viking character (often mistaken for a heavy metal guitarist), or perhaps a tall and gaunt elfin type. A male character might have the imperial bearing of Finvarr, King of the Tuatha, or the brutal features of the Bergtrolls, the mountain trolls of Scandinavia.

MALE FIGURES

There is a rich and colorful tradition of fantasy characters in every mythology around the world, and you can read innumerable stories of all kinds of weird and wonderful beings to inflame your imagination and inspire your art.

All fantasy art is liable to be of an epic nature, so prepare yourself by getting inspired: immerse yourself in the world of books, movies, and art inspired by mythology from around the world. It's a good idea to start with books and allow words, not images, to conjure up characters in your imagination, rather than copy what you see in other media.

But to begin with the basics, most male fantasy characters have one head, two arms, two legs, and a torso.

HELMETED HERO
Your characters will all be different, but the principles behind drawing them will be the same.

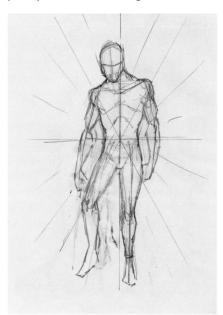 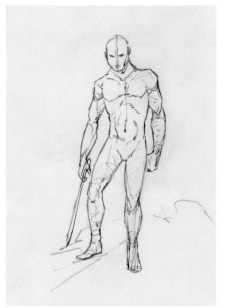 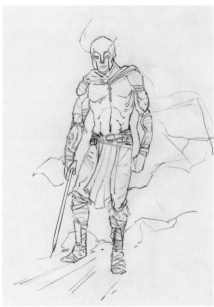

1 This composition uses a centralized and symmetrical perspective that gives the figure a strong, steady stance. Roughly draw the basic body parts. A typical hero will have broad shoulders and a wide torso tapering to a slimmer waist. Note that the shoulder muscles will be exaggerated. You can consider tilting the head slightly to give the figure an intimidating presence.

2 Begin to work in the details of the musculature. A lot of this detail will later be covered by clothes or armor, but it will show through and add realism to your drawing. Give some thought to what the hands are doing—for example, if they are carrying a weapon, consider the weight of that weapon and the type of grip required.

3 You can see here how a good preliminary drawing will make it easier for you to add clothes; you can see the swish of the fabric and the rough outlines of how the armor appears to fit to the body. Work loosely at this stage and play around with ideas such as the belt, bracelets, and boots. You can also consider the weather. Here, the wind is catching the cape, which adds flair to the image.

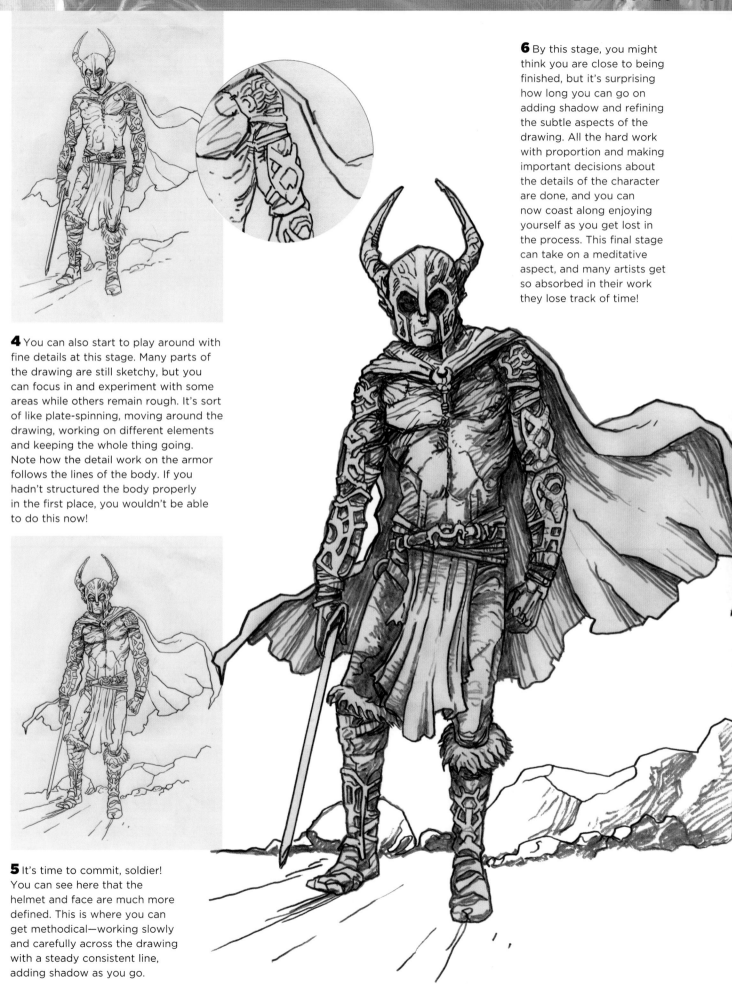

6 By this stage, you might think you are close to being finished, but it's surprising how long you can go on adding shadow and refining the subtle aspects of the drawing. All the hard work with proportion and making important decisions about the details of the character are done, and you can now coast along enjoying yourself as you get lost in the process. This final stage can take on a meditative aspect, and many artists get so absorbed in their work they lose track of time!

4 You can also start to play around with fine details at this stage. Many parts of the drawing are still sketchy, but you can focus in and experiment with some areas while others remain rough. It's sort of like plate-spinning, moving around the drawing, working on different elements and keeping the whole thing going. Note how the detail work on the armor follows the lines of the body. If you hadn't structured the body properly in the first place, you wouldn't be able to do this now!

5 It's time to commit, soldier! You can see here that the helmet and face are much more defined. This is where you can get methodical—working slowly and carefully across the drawing with a steady consistent line, adding shadow as you go.

Of all fictional genres it is, perhaps surprisingly, fantasy in which female characters have the widest and most progressive range of archetypes. In other genres, such as thrillers or action adventure, female characters are often relegated to the roles of love interest, sidekick, trophy, or pseudo-male.

FEMALE FIGURES

Fantasy fiction has all these roles and many more: The goddess figure, aloof and untouchable, who rises above the petty struggles of mere mortals; the wise old woman, cranky and eccentric, who cares nothing what people think of her and dispenses her wisdom only to those deemed worthy; the ingénue, the innocent star child, pure of heart, who is determined to find her own path in life irrespective of what society has decreed for her; and the cruel witch or sorceress, bent on power, manipulation, and greed. The list is endless, and it is with female characters, in particular, that you will often find the most interesting qualities and paradoxes of behavior.

A great source for beautiful anatomical depictions of both female and male figures is figurative sculpture from many eras and cultures. The fact that these objects are three-dimensional gives us a great resource of both shadow and form and, as they are captured frozen in a moment, you will see beautiful renderings of clothes and hair, too. From the masterpieces of Michelangelo to the exquisite beauty of Thorvaldsen, and the dark power of Rodin, or the highly erotic temple carvings at Khajuraho in India, there is a rich vein of inspiration to be mined for your art.

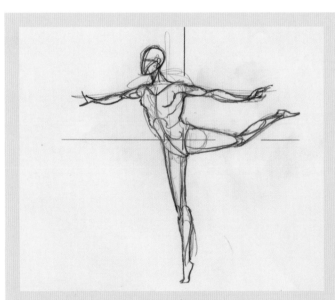

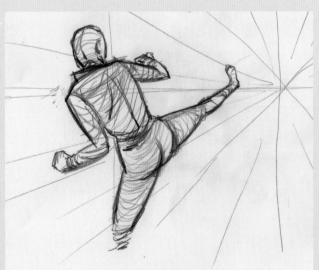

▲ CENTER OF GRAVITY

Knowing the center of gravity is essential to depicting any combat pose. It is the point at which the weight and balance of the whole body is distributed. The center of gravity moves toward the floor in a line called "the line of gravity" and the parts of the body around the center of gravity balance each other out like the arms of an old-fashioned scale or balance.

▲ FORESHORTENING

This kind of extreme foreshortening can be hard to depict. One of the best ways to practice is to use a DVD of an action movie, pause it at a key point and draw from that. *The Matrix* and *Tomb Raider* movies are very good sources. You can copy the basic poses without being derivative and add your own fantasy details.

FEMME FATALE

Starting with loose sketches and gradually tightening up your drawing is a great approach for figure drawing.

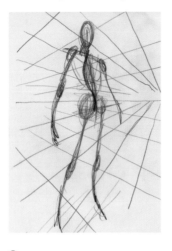

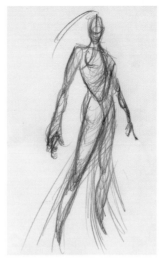

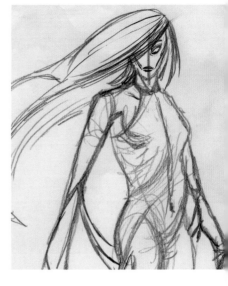

1 As always, a rough sketch or study will help you decide the pose and character of your figure.

2 Base your perspective guidelines and basic stick figure on your study sketch. Note how the lines are flowing and energetic— female figures tend to have more curves than males!

3 Add the basic volumes. For a classic beauty, you will need a small waist and a circular area that will become the hips. The neck should be longer than for a male, and note the smaller head in comparison to the body.

4 Start to add the shapes of the hair and clothes. You can see how the basic volumes in the last step and the basic lines of the first step contribute a great deal to the flow of the dress and hair.

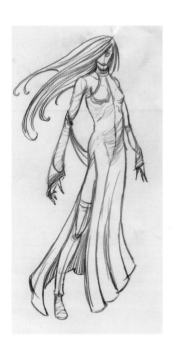

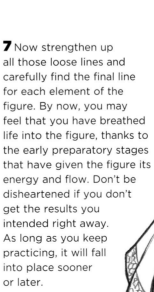

5 Use a succession of quick, loose, curving lines that breathe life into the whole drawing to add more detail to flowing elements such as the hair and dress.

6 Focusing in to work on the fine details may be the hardest part of any drawing. Both faces and hands are vital to any figure artwork, and if they don't work, the whole piece will suffer. To make it even harder, these elements are always comparatively small, so draw big and do several studies to be sure of your approach. The use of a lightbox comes in very useful here, as you can try several versions of the same drawing before committing to your final piece.

7 Now strengthen up all those loose lines and carefully find the final line for each element of the figure. By now, you may feel that you have breathed life into the figure, thanks to the early preparatory stages that have given the figure its energy and flow. Don't be disheartened if you don't get the results you intended right away. As long as you keep practicing, it will fall into place sooner or later.

Since many of your combat figures will be wearing armor, it is important to learn how to draw this convincingly—how it is constructed and fits together, and how it wraps around the body.

ADDING ARMOR

Most of the fantasy armor we see today is loosely based on European medieval armor, but it should always have fantasy flourishes added from other periods or from your own imagination. See pages 78–81 for examples of the rich and diverse traditions of historical armor that are available for artists to use as reference.

FOLLOW FORM
Think about the shape of the body when drawing armor.

1 The pose of your character should show that they are wearing armor and carrying weapons, which will be heavy! Draw the positions of their legs and feet to show that they are compensating for the weight they are carrying.

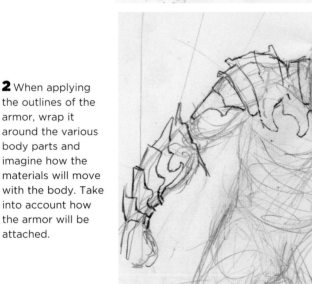

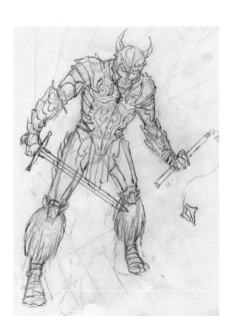

2 When applying the outlines of the armor, wrap it around the various body parts and imagine how the materials will move with the body. Take into account how the armor will be attached.

3 Armor is usually a mixture of heavy plate metals and tough materials, such as stiffened leather, with movable parts at the main body joints. You can add your own embellishments, such as decorative scrollwork etched into the metal, or attach spikes and blades.

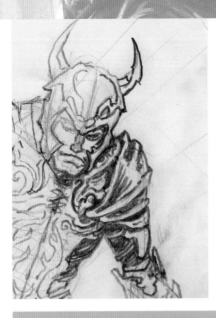

4 Be sure to add shadow underneath the edges of all the armor parts and draw in additional details before considering how you wish to treat the armor to give a metallic effect.

SIMPLE METALLIC EFFECTS

Add shadows and highlights to the armor to give the impression of the effects of light on metal. There are many techniques for doing this depending on the medium you are working in. Here's a simple method using a pencil.

1 Begin by drawing the basic overlapping plates in outline. Add rims and fixings if you wish.

2 Add basic shadows using curved shapes that follow the contours of the volumes. Remember to place heavy shadows underneath, where the plates overlap.

3 Now try adding highlights by removing areas of shading with a fine eraser. You will see that this immediately "lifts" the look of the armor and creates a shiny effect. You can also add dents, scratches, and flecks of rust.

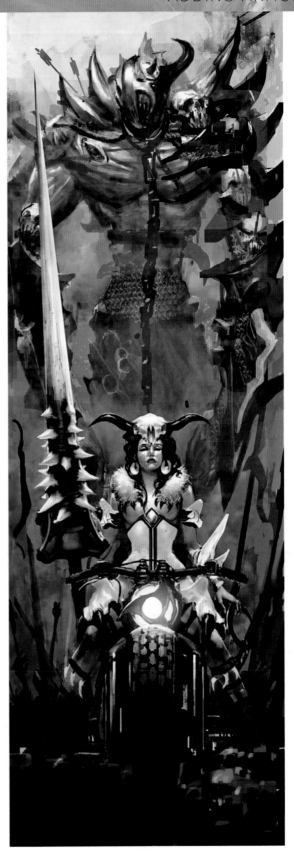

▲ STYLIZING ARMOR

Corrupted by Nikolay Yeliseyev shows an inventive and original design for the heroine's armor, with a bearclaw fur collar and an impressive, if perhaps unwieldy, lance that appears to have been stripped from the tusks of some strange and fantastic monster.

It is the face that we most strongly identify with—it tells us everything we need to know about the character, their mood, and intentions, and these details often tell us the story behind any single image.

FACIAL FEATURES

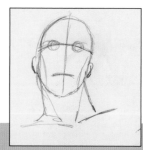

When creating characters for the fantasy genre, animation and comic companies often have their artists working pencil on paper for weeks or months to define the characteristics of a single character. Great character design only comes from endless repetition. If you don't like drawing the same person over and over again, then character design is not for you!

ANGLES

When a face is seen from a low angle, it appears foreshortened. Draw the line for the eyes as a downward curve like a bridge, and place the ears lower than in a straight-on view. When looking down on a face, draw the line of the eyes curved upward. The eyes are covered by the brow so the eyebrows appear lower. The nose points noticeably downward with no nostrils visible.

FRONT VIEWS

1 Begin with an oval shape and hang the jaw from it. Use a center line for symmetry and draw in a crossbar for the brow. Add the eyes as single spheres.

2 Add the pupils first, then wrap the eyelids around the circles as if you were wrapping fabric around a tennis ball. This helps to lend more realism. Build the nose from a triangular shape.

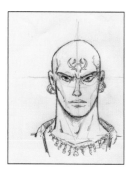

3 Work over the lines to strengthen them. Add shadow beneath the jawline and under the brow.

SIDE VIEWS

1 Begin with a flattened circle for the skull and hang a jawline from it. Male hero figures are more liable to have a large, strong jaw. Draw the brow with a straight line across to the ear and place the eye under it as a complete circle. Note the rough lines for the cheekbone.

2 Start to add the detail. Try out different types of noses, large and small. Add the mouth as a single straight line before adding any lip detail.

3 Add areas of shadow, flesh out the lips, and go over the lines, darkening them as you go. Draw hair in the direction in which it hangs or flows.

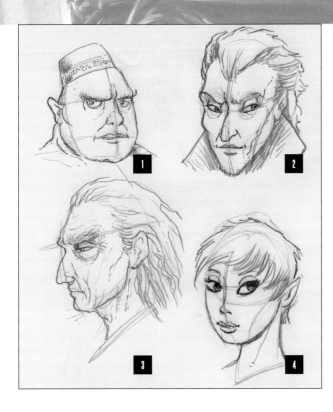

FACE TYPES

A fleshy face has the same basic skull shape as any other, but you will need to add more flesh onto it. Imagine the cheeks are stuffed with pillows and work with spherical lines to achieve the look (1).

A thin face is likely to have well-defined cheekbones and a much narrower jaw than that of a heavier person (2).

An older face will have a normal skull, but age is conveyed by the execution of the lines. As people grow older, the muscles in the face become slack and start to sag. The ears and nose continue to grow so they become proportionately larger in relation to the rest of the face (3).

Younger characters and elves (who tend to look very youthful) have comparatively large eyes and small noses and mouths. The cranium is also large in relation to the jaw and the neck appears more slender (4).

Then, of course, you have the myriad denizens of your imagination to visualize. Create your own fantasy species by giving your characters any human features you choose combined, for example, with horns, scales, spikes, or cat's ears.

THREE-QUARTER VIEWS

1 With three-quarter views it helps to imagine the skull as a squashed tennis ball shape and look at it as though it is a sphere. Wrap the eyeline around the center of the sphere and place the eyes and ear accordingly.

2 Add a vertical center line to guide the positioning of the nose and mouth. This can be difficult to master, so refer to photographs to help you.

3 Fill in the details and add shading, bearing in mind the irregular spacing between and size of the features.

EXPRESSIONS

Needless to say, the number of actual expressions is almost infinite—there are forty-two muscles around our mouths alone, so you can have endless fun working out new and interesting expressions to breathe more life into your characters.

Sinister features are essential part of the repertoire of any fantasy artist. A low angle with heavy arched eyebrows and a downcurving mouth will help (1).

A coy sideways glance is guaranteed to melt the heart of even the most battle-hardened hero—and won't go unappreciated by his band of merry comrades (2).

The depiction of anger often requires an open mouth. The eyes can be narrowed to slits. The head juts forward (3).

There's not much need for happiness in the average fantasy tale, except at the end when evil has been vanquished (4).

There's plenty of room for the brooding thoughtful type in fantasy art. All that sitting around in darkened halls waiting for messengers leads to this kind of disposition (5).

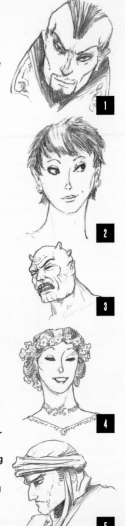

There is an endless variety of small details you can use to differentiate your characters and give them a specific look or feel. In film and fashion this is referred to as "styling" and there is a whole industry built around it. The art of good styling is in the attention you give to tiny details that can say a great deal about a character, even if you only see them for a second.

CHARACTER DETAILS

Imagine Tony Stark's signature beard and mustache in *Iron Man* or more subtle details such as the cuffs of a jacket or the shape of a shoe. From tattoos and piercings to hairpieces and makeup, every detail adds up to an impression that defines your character. Even the shape of hands and feet can say a great deal about a character, as can body shape and body language.

JEWELRY AND ACCESSORIES

No Queen of Darkness or Princess of Light would be seen in public without some exquisitely designed piece of jewelry or adornment that defies gravity and probably took a team of servants to help her put on in the morning. Don't limit yourself to the traditional Celtic imagery most often used in the fantasy genre. There is a wealth of designs from around the world to use as a starting point for your own creations.

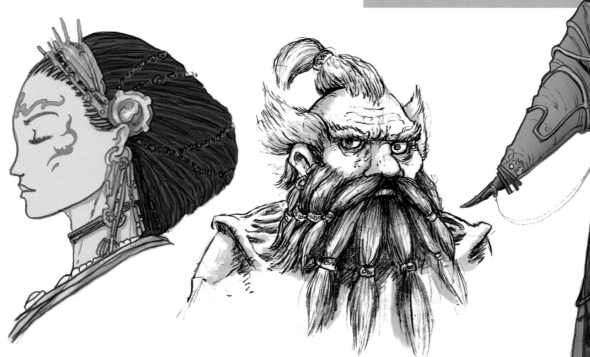

▲TATTOOS AND PIERCINGS

Tattoos and piercings are big news in fantasy art and film, which have plundered Viking and Anglo-Saxon body adornment to great effect, often adding new twists.

▲HAIR EXTENSIONS AND BEARDS

No self-respecting fellowship of heroes will set out on a quest without the requisite number of outrageous beards and extravagant hairdos (or should that be hair dont's?).

▼ DESIGNING JEWELRY

Here Finlay Cowan chose a theme rather than attempt to design a specific type of jewelry. In this case he set the theme of a wood goddess called the Birch Maiden, so all the forms were depicted as twig and leaflike and the whole style and look followed through from that concept.

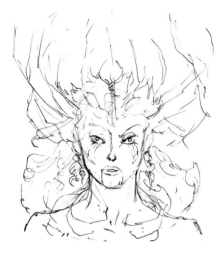

1 Jewelry may appear to be complex and detailed, but this initial sketch shows that the artist has thrown down a lot of loose lines and shapes first without too much thought given to the final details.

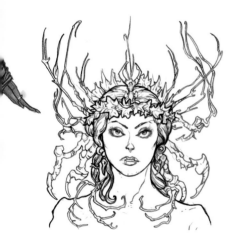

2 In the final drawing the shapes can be "found" as you go along with successive sweeps of the drawing. You can also see that, if you approach the drawing with a certain confidence, you don't even need to make things symmetrical or match up!

HANDS

You may not consider hands to be indicative of character, but they can be extraordinarily expressive and say a great deal.

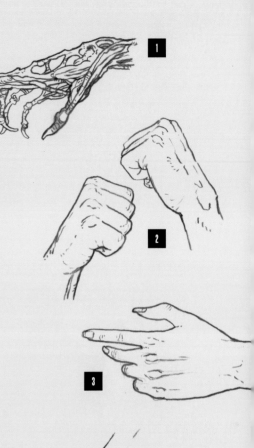

The weirdo hand, the more gnarled and spiky the better, is used by witches and warlocks to lure our heroes into a trap of some description. It's useless for fastening buttons but that's usually the least of its owner's concerns (1)!

The closed fist is all-important in combat art—notably for punching out orcs or for slamming on the table to make a point (2).

Goddesses and spirits use the pointing hand to direct the hero toward his destiny—usually during that dark moment when he is lost in the woods and his fellows have deserted him after an argument over a ham sandwich or something similar (3).

Use an open hand for running over maps, finding hidden latches in carved temple doors, and hailing fellow adventurers (4).

The gripping hand is essential in combat art, as few heroes or villains will be seen without gripping the shaft of some weapon or tool (5).

The grabbing hand is useful when swinging from chandeliers in bar fights, but is also needed by the villain to cling desperately to the side of the pit while being dragged back into the fiery underworld. This pose is also useful for the casting of spells (6).

MAKING YOUR COMBAT SCENES REAL

3

*"If you know the enemy and know yourself,
you need not fear the result of a hundred
battles. If you know yourself but not the
enemy, for every victory gained you will
also suffer a defeat. If you know neither
the enemy nor yourself, you will succumb
in every battle."*

Sun Tzu (ca. 400 B.C.)

Combat can be divided into three subsections and then subdivided further into specialities.

TYPES OF COMBAT

Warfare involves two or more military forces in conflict with each other. There are three basic categories:
• Nation to nation: Two or more opposing countries in conflict.
• Guerilla warfare: Suppression of a nongovernmental military organization by a government.
• Civil war: Opposing forces of rival governments within the same country.
 Your choice of these will help give you ideas for the setup of your battle scenes and influence settings, costume, and drama.

Battle itself can be divided into armed and unarmed combat.
• Armed combat uses range weapons such as guns, bow and arrow, trebuchet, and so on... anything you can use to kill somebody without having to smell their breath.

• Unarmed combat consists of hand-to-hand combat—that is, fighting at close range using the body or what is known as melee weapons, such as swords, batons, knives, and so on (which undermines the term "unarmed," but I don't make the rules).

When setting up your battle scene or sequence, you should next consider the various types of combat that you want to depict. By looking at traditional modes of combat you can provide yourself with a wealth of material that will add a sense of reality and provide detail to your work.

Unarmed combat may consist of three further subdivisions:
• Clinch fighting
• Ground fighting
• Stand-up fighting

▲ MOUNTED COMBAT

Close-quarter combat with horses is a staple of the fantasy combat genre and adds drama and intensity to a fight scene, as this painting by Raymond Minnaar shows.

▼ CLINCH FIGHTING

In clinch fighting, the opponents grapple with each other using a variety of holds and throws of the kind you might see in a judo match. This technique aims to stop the opponent's use of kicks, punches, and melee weapons and will use throwdowns or sweeps to disarm him.

▼ GROUND FIGHTING

In ground fighting, unarmed opponents are usually thrashing about on the ground. Imagine the kind of techniques you see modern army soldiers or special agents in movies using, including chokeholds, fish-hooking, eye-gouging, joint locks, pressure point techniques, and various strikes.

▼ STAND-UP FIGHTING

Stand-up fighting includes unarmed combat and combat with melee weapons such as knives and batons. Boxing, karate, and kendo are all forms of stand-up fighting. The exact nature of the combat depends on the distance between the opponents: batons are not much use at close range as they cannot be swung very well, but knives are perfect for close-up use (for obvious reasons).

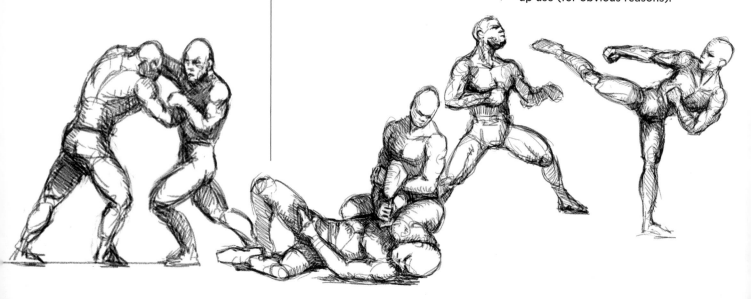

SWORD FIGHTING

One-to-one sword fights are probably the most common type of stand-up fighting in fantasy combat art. When planning a sword fight consider whether your opponents will be carrying heavy blades for hacking and slashing, fine swords for more skilled techniques (as in this image by Matt Stawicki), longswords or short swords, or highly specialized weapons such as samurai swords.

The figures are seen in a classic striking and blocking action (1).

The upper figure is in a defensive position, but has the upper hand since he is higher than his opponent; his return strike will carry considerable weight behind it (2).

The characters wear traditional sword-fighting clothes. Loose shirts are intended to hide the contours of the body and make contact less likely, whereas tight waistcoats offer some protection while allowing for ease of movement (3).

Look for reference material on various sword-attacking and defensive stances, such as those used by samurai, taekwondo, and medieval long-sword fighters (4).

All art instruction books will tell you how important it is to learn the skills required to depict good anatomy (see page 38), and you must learn the basics of human anatomy before breaking those rules and creating your own wild and wonderful humanoids and superhumans, magical beasts, and supernatural beings.

HOW THE BODY BENDS AND FLEXES

Fantasy combat art takes anatomy to a whole new level; good anatomy means good combat art and, as we all know, anatomy drawing is not easy. But don't despair—"the journey of a thousand miles begins with a single step" and "Helm's Deep wasn't built in a day." It may take some time, patience, and dedication, but there are a host of tips and tricks to make the process easier for you, and the first step is to categorize the poses of your characters as you begin to develop ideas for your battle scene.

The three main elements of combat anatomy are:
• Balance
• Movement
• Dynamic tension

All these elements have an influence on how the body bends and flexes. You may wish to massively exaggerate the musculature of your characters, you may add extra limbs, they may have dog heads or bat wings, but whatever you do, the bodies you draw will still need to twist and writhe in a way that is believable.

DEFINE YOUR POSES

When you have made the following decisions you can go on to define the positioning of your combatants.
• **What type of combat are you depicting (see page 56)?**
• **Is it a war or battle with numerous characters involved?**
• **Does it involve humanoid versus humanoid or humanoid versus beast?**
• **Is it armed or unarmed combat?**
• **Is it one-to-one fighting or one against many?**

▼ BALANCE

Balance is a key element of any action pose. If your character is carrying a gigantic two-headed ax, it's going to affect his balance and you need to show this in the pose. Likewise, drawings of any character jumping, running, or even just standing all require a center of balance.

▶ MOVEMENT

The body bends and flexes, moving in accordance with our actions. In combat scenes, your characters are engaged in a desperate life or death struggle, swinging weapons, deflecting blows, and throwing punches. Begin with a series of stick drawings to learn the basics of movement, then add musculature as you become more confident.

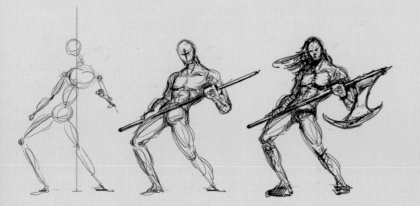

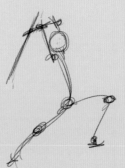

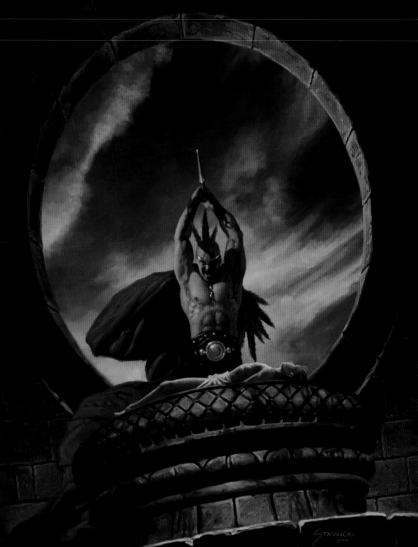

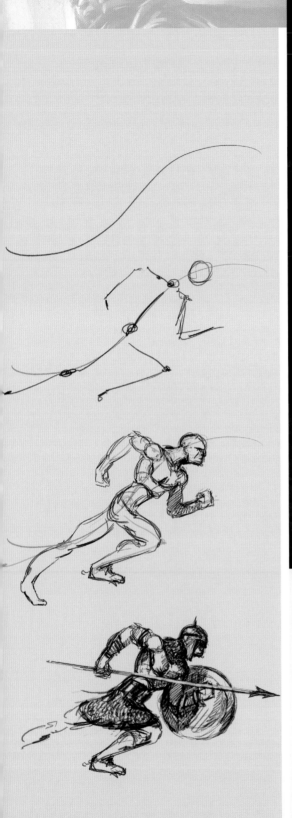

▲ DYNAMIC TENSION

Dynamic tension is the flow of movement that breathes life into your drawings. Begin by making quick sketches showing the line of movement through the body, then build up the figure from there.

USING DYNAMIC TENSION

The dynamic tension of this image, *Bloodstone* by Matt Stawicki, has been captured in a split second. One figure is highly active while the other is passive. We can see the tension in every muscle and expression.

The body is very symmetrical, which is in keeping with the combat move: that of striking downward with a double-handed motion (1).

The head is bowed, as is correct in such a pose (2).

The expression of the character is that of furious intensity, perfectly illustrating the moment (3).

The musculature is clear and well-defined with heavy shadows on one side, bringing the curvature of the body into stark relief (4).

The victim is depicted with flowing lines and soft contours; we see none of the physical tension that is apparent in the male figure, and this creates an interesting contrast (5).

▼ SUBVERT EXPECTATIONS

Instead of depicting the warrior in a victorious pose, in this painting Matt Stawicki portrays him as downcast and remorseful. This raises numerous questions in the viewer's mind, creating a much more interesting image.

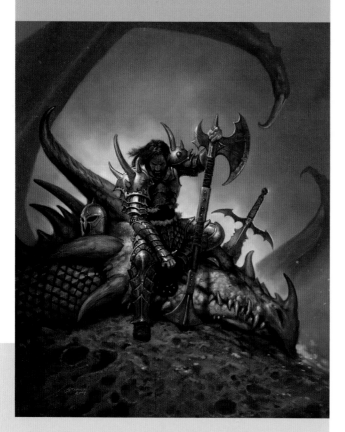

▼ USE YOUR SKETCHBOOK

Explore some of the countless possibilities within the four categories before making your choices. Those listed above are just a few of the immense number of options. See how many interesting variations you can come up with.

There are four basic categories of action pose: Static, action, attacking, and defending.

POSES AND POSITIONING

Static stances include a variety of options: Think about the distance between the feet—short stances are better for agility, whereas long stances are better for stability. Consider what stance your character would use. For example, dwarves are stocky, so they are less likely to be seen crouching, but a cat-like ninja warrior is more likely to be seen creeping or crawling. Examples include: Standing, crouching, crawling, and defense stances.

When thinking about action poses, you need to consider the angle from which you view the figures. If they are leaping through the air, will the viewer be beneath or above them? Begin with a series of fast sketches, work quickly, and keep them loose and expressive. Examples include running, leaping, lunging, springing, and flying.

When tackling attacking poses, you should be thinking about transferring energy. The figure will be putting force into their action. Examples include lunging, throwing, slashing, hacking, punching, and charging.

Look at the many online resources for simple drawings and photos of defensive positions and you will see that stance and the center of gravity are the key to illustrating figures in defensive poses. You can also make decisions about what stage your combat scene has reached; is the opponent injured, crawling away, in a position of surrender or, indeed, dying... horribly. Examples include blocking, kneeling, crawling, begging, and dying.

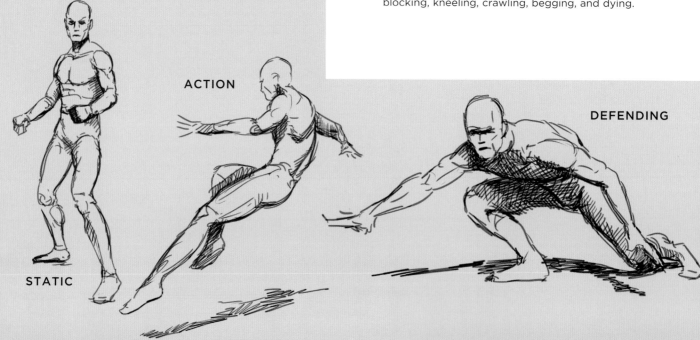

ACTION

DEFENDING

STATIC

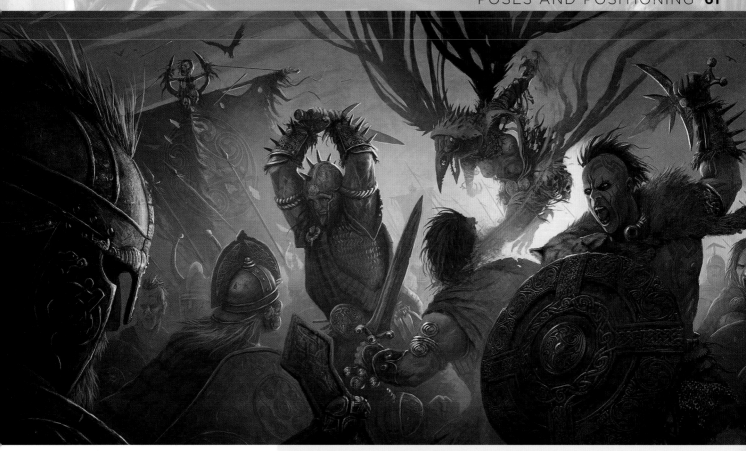

COMBINING POSES

This image by John McCambridge features several fighting stances and includes both human and non-human combatants, which adds variety to the image. The styling of the figures raises questions in the viewer's mind as to who and what they are, and the circumstances that led to this moment. While six figures are depicted in detail, the artist has cleverly given the impression of a major battle scene by including shadowy elements in the background that indicate the presence of a much larger fighting force.

The larger figures around the edges have been cropped and this leads the eye to the action at the center of the image (1).

The large framing figures have been executed with more shadow in order to enhance the action further (2).

The main action figures are largely "backlit," creating depth of field and showing silhouetted spears and banners in the distance (3).

Two of the three figures facing us are in attack poses with their weapons raised and their bodies tensed for action, as shown in their musculature and anatomy (4).

The third facing figure is a crow-like ghoul, who has already struck. Note the compositional tension created by the three attacking figures (5).

ATTACKING

Attacking poses vary enormously depending on the type of combat and the equipment used. Be sure to consider martial arts, swordsmanship, unarmed combat, and melee fighting, as well as archery, armed combat, and various other combinations, including stick fighting, kickboxing, and the use of longer-range weapons such as blowguns and catapults.

DIRECTORY:
ATTACKING POSES

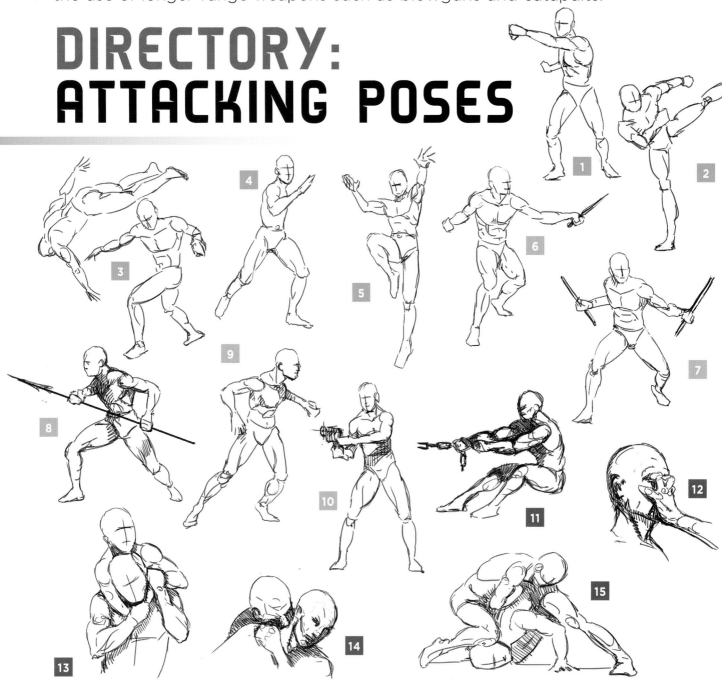

Unarmed combat includes light contact such as:	Stand-up or melee fighting may include:	Ground fighting may include:	Sword fighting may include:
1 Punching	6 Stabbing	11 Ramming, pushing, or pulling	16 Thrusts
2 Kicking	7 Beating with sticks or batons	12 Eye gouging	17 Swings
3 Throwing	8 Spear use	13 Chokeholds	18 Blocks/parries
4 Chops	9 Lunging	14 Biting	19 Two-handed ax blow
5 Leaping	10 Shooting	15 Wrestling/grappling	20 Two-bladed ax

Static poses may include:

Other useful attacking poses include:

21 Triumphant stance
22 Weapon raised for attack
23 Crouching for attack
24 With drawn bow
25 Holding spear

26 Charging
27 Swooping (as in flying)
28 Various running poses

Defensive poses offer a variety of interesting options but, as a general rule, all depend on the combatant bracing themselves. You will need to consider their center of gravity—the combatant will require a strong footing as they anticipate the full force of their attacker's sword, ax, or club bearing down on them.

DIRECTORY: DEFENSIVE POSES

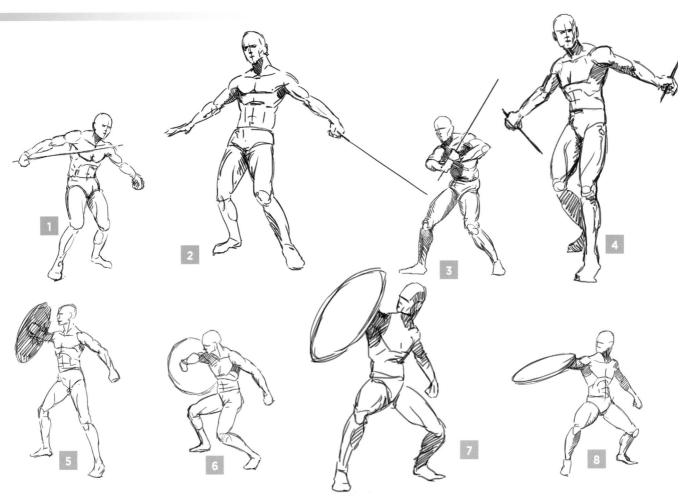

Blocking/parrying with a sword:	Blocking with a shield:	Blocking with the body:	Other useful defensive poses include:
1 Sword parry high	5 Shield block high	9 Forearm block	13 Rolling in or out of attack
2 Sword parry low	6 Shield block low	10 Leg block, trip, or sweep	14 Pinning
3 Two-handed parry	7 Shield block against dragon breath	11 Shoulder block	15 Twisting in or out of attack
4 Using two swords to block	8 Shield thrust	12 Crossed wrist block	16 Using an invisible cloak
			17 Begging for mercy

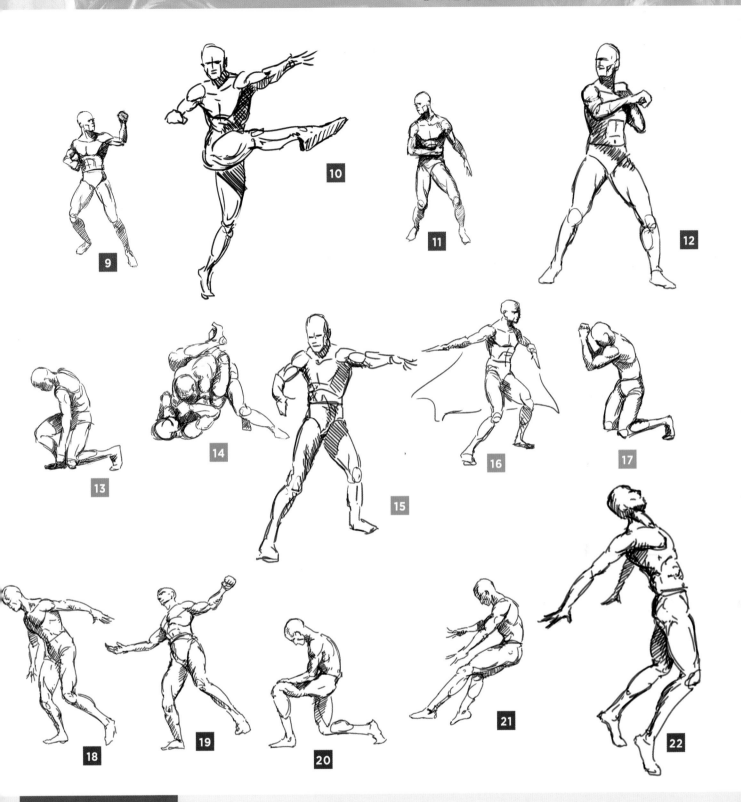

Defeat poses may include:

18 Stumbling
19 Falling backward
 or forward
20 Kneeling
21 Receiving a blow
22 Receiving a stab
 or sword thrust

Before you begin to draw the settings and backgrounds for your combat scenes, it is important to understand how the environment around you is constructed and how it appears to your eye.

PERSPECTIVE

We perceive the world around us as three-dimensional, with objects that have height, width, and depth. The way we determine their scale, how far away they are, and where they are in relation to each other is based on two things. First is the level of the horizon line, where (so long as nothing gets in the way) the landscape would stretch off and disappear into the distance. The second is the location of one or more vanishing points along that horizon line or elsewhere. By having the edges of objects leading toward common vanishing points, we can build up a three-dimensional picture.

DRAW THE VIEWER IN

Foreshortening in battle scenes can be hard to achieve at first, but is essential for increasing the power and excitement in an image, as here in *When the Saints* by Matt Stawicki.

Here, we are at an extremely low angle looking up toward the hero, who is leaning heavily forward over us; note that he is largely in shadow (1).

The castle walls veer away at sharp angles upward and to the left and right—this all adds to the power of the scene (2).

The low angle means more sky, which allows for more background action such as the archers on the battlements (3).

Flying objects such as arrows or the sword shown here add further depth to the perspective of any scene's background creating depth of field across the painting (4).

▶ ONE-POINT PERSPECTIVE

When both the viewer and the object viewed are on parallel planes, you can only see one side of the object and there will only be one vanishing point, so this type of perspective drawing is called one-point perspective. To construct a cube in perspective, draw a square on the picture plane parallel to the horizon line, and project lines from each corner to a vanishing point. Choose a point along one projected line and draw another square, bounded by the projected lines. This forms the back surface of your cube. Here, the lines have been drawn downward from the vanishing point so that we appear to be looking down on the cube from a bird's-eye view.

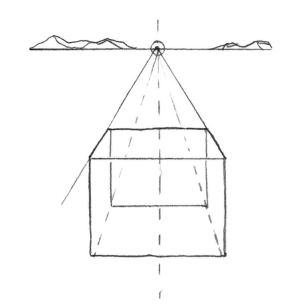

▶ TWO-POINT PERSPECTIVE

When an object is viewed from an angle, there will be one edge or corner that is closer to the viewer; this is called the leading edge. Both sides of the object that recede from this leading edge will have their own vanishing points. This type of perspective drawing is called two-point perspective. To construct a box in two-point perspective, draw the horizon line and add two vanishing points anywhere along it. Project lines outward from the vanishing points, and the place where they meet on the picture plane is the leading edge. Add vertical parallel lines to construct a box. In this example, the viewpoint is at the same level as the horizon line, so the box appears to be at the same eye level as the viewer.

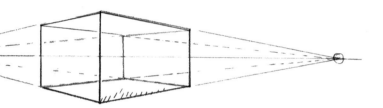

▶ THREE-POINT PERSPECTIVE

As the name implies, three-point perspective adds a third vanishing point. This enhances the impression that we are looking up or down at an object. The third point is not placed on the horizon line like the other two, but above or below it instead. Three-point perspective often requires that the first two points be widely spaced. You might find that, in order to get the angle you are looking for, your perspective points are off the page. This may be hard to deal with at first, requiring you to draw the points on your drawing board and use a very long ruler, but eventually you will be able to judge perspective without using a ruler at all. In fact, once you have mastered the rules of perspective, you will be able to break them by twisting perspective and changing it to create different visual impressions, as some of the examples here demonstrate.

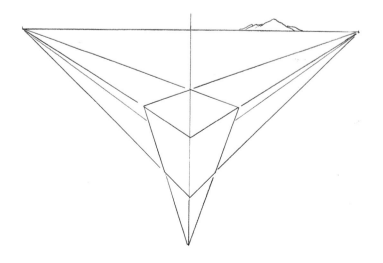

All fantasy characters stand around eight heads high as opposed to six or seven, which is the normal human proportion—and that's just the heroes! When you start to create muscle-bound barbarians, ogres, and superhumans of every type, it just gets more absurd. So build upward and outward, but stick to some basic rules.

EXAGGERATING THE HUMAN FORM

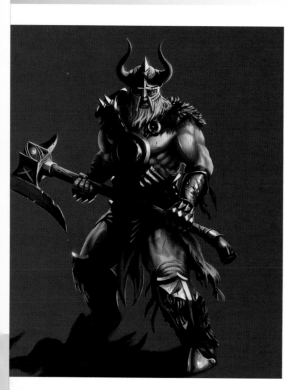

The muscles of the trunk and torso are broad and wide and those muscles in the arms and legs are long. By all means, stretch muscles upward and outward but, generally speaking, maintain the same relationships between the muscles, unless you are intent on creating an entirely new species.

By simply enlarging or reducing key facial features such as eyes, lips, nose, and ears, you can create interesting new

◀ MUSCLES
By supersizing muscles you will arrive at the proportions of an ogre or barbarian type, as in this image by Raymond Minaar. Stick to the standard relationships between body parts to begin with: the chest is usually wider than the waist; the arms reach the top of the thighs when hanging straight, then start to elaborate.

variations on the human species— for example, hobbits (big feet), elves (pointy ears and high cheekbones), and dwarves (big noses and ears).

Imagine that the skeleton is the architecture on which the figure is hung. If you extend the length of the legs and arms, you develop an elfin species. If you reduce the overall size you end up with fairies; if you broaden everything you have an ogre. Consider what other variations you can invent. Could you give a broad-chested ogre type long, skinny arms and legs? It might look crazy, but you must experiment in order to create new archetypes.

Each creature that you create will have its own combat qualities, so while you are developing these characters, you should also be asking how they fight, what their skills are, and what type of weapons would they have developed to suit their specific physical qualities.

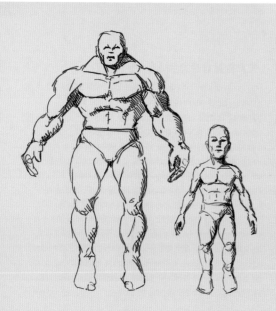

SKELETON
By enlarging the head of a figure, you can make it look more humorous, as with dwarf-like creatures. Large heads can also make characters look more childlike and thus more cute or friendly. By reducing the head of a large-bodied character, you can make them look less intelligent, and the result is an ogre type. By reducing the head size of a standard figure, you can make him or her look taller and more elf-like.

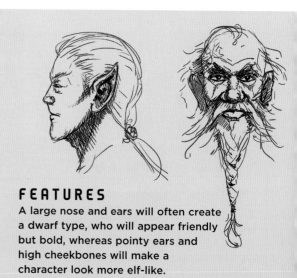

FEATURES
A large nose and ears will often create a dwarf type, who will appear friendly but bold, whereas pointy ears and high cheekbones will make a character look more elf-like.

▼ VARIATIONS

Try deviating from the normal archetypes and explore other possibilities, such as lengthening the neck or adding features from the animal world, such as deer antlers, fish gills, or tusks, to add variety to your characters. The more exaggerated the additions, the more interesting they might become.

- Horns and antlers
- Scales and fins
- Tusks and spines
- Fur and feathers
- Hooves and claws

STOCKY TYPE

The classic barbarian such as Conan is the perfect example of the exaggerated human form, with his barrel chest and bristling biceps, as shown in this image by Matt Stawicki. His minimal clothing is surely chosen for practicality, but it allows the artist to show his impressive musculature in great detail. Besides, if you've got a body like that, it must be difficult finding clothes that fit—his thighs are almost as wide as his waist. Where's he going to find chinos with that kind of tailoring?

The low angle of the drawing emphasizes the barbarian's stature and his massive physical power (1).

The strong light source from the top right has been well considered. It has allowed the artist to throw the figure's musculature into relief (2).

The heavy beams in the background assist the composition, guiding the eyes to the figure. And the positioning of the opponent in the foreground and the maiden in the background also contribute to the sense of sheer power emanating from the mighty hero (3).

The world of myth and fantasy is infinite and there are no limitations regarding the creation of fantasy combatants. Classic archetypes have developed through the ages. Every good story or image requires these archetypes, but it's also important to imagine new kinds of heroes, villains, and monsters.

DIRECTORY:
CLASSIC COMBATANTS

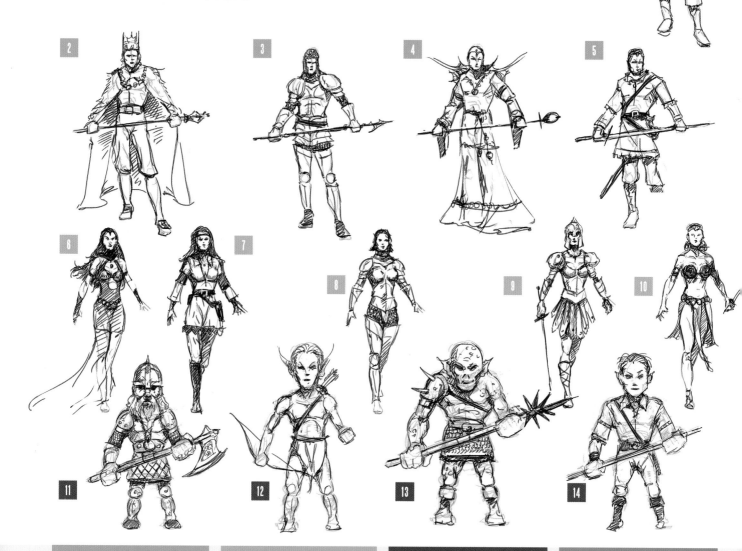

Classic hero/villain may include:	Classic heroines may include:	Short and stocky	Big and beefy
1 Knight	6 Sorceress	11 Dwarf	15 Temple guard
2 King	7 Woodswoman	12 Fairy	16 Dragon lord
3 Warrior	8 Knight	13 Orc	17 Death knight
4 Wizard	9 Warrior	14 Elf	18 Warrior
5 Archer	10 Fantasy princess		

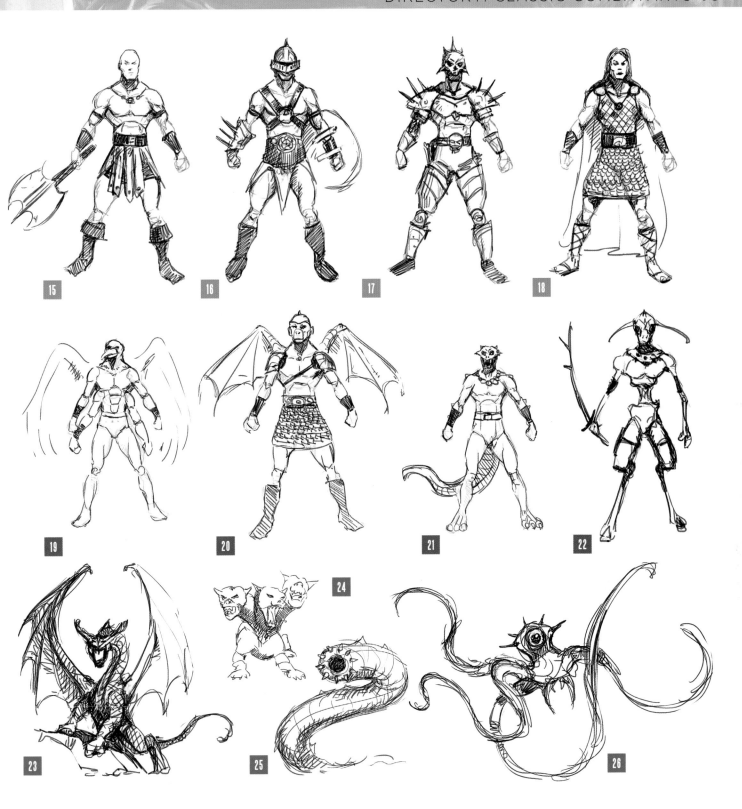

Humanoid fighters	Non-humanoid fighters
19 Crow-headed revenant	23 Dragon
20 Flying monkey	24 Three-headed dog
21 Lizard man	25 Behemoth
22 Wraith	26 Amorphous blob

Almost all action between figures in a combat scenario involves a flow of movement through the characters and an energy transfer between them.

ENERGY TRANSFER AND FLOW

The swordsman raises his weapon and applies the force of his energy into it, creating a momentum that brings the sword down. The energy built up in the movement is then transferred across into the weapon or shield of his opponent. The combatant with the greatest reserves of energy may be at an advantage, but the combatant who has the best focus and control of his energy may also win, even if he is not as strong. Energy thus flows between the figures and you can use this approach to enhance the dynamic action in your artwork.

OUTGOING ENERGY

1 The figure holds the spear poised to launch it. In this composition, you must consider the hold on the spear: it is balanced and therefore there is no energy being transferred to it. Similarly, the figure stands in such a way that it is clear that he is not gathering energy for the throw, but is technically "at rest." Nevertheless, there is evidence of mental activity here, as the combatant focuses on his target.

2 The combatant draws back the spear ready to strike. Here we can see the tension in the body. The legs are firmly planted and are about to twist into the throw. The body is gathering and storing energy, which will be released at the moment of the throw.

3 The spear is launched as the body rotates forward. Imagine a line of energy surging upward from the ground, gathering through the body, and being transferred into the spear. The body recoils, much like a rubber band after it has been snapped, with the left arm swinging loosely backward, the stored energy having been released. After the throw the body will lurch forward, but without the pent-up tension of before the throw.

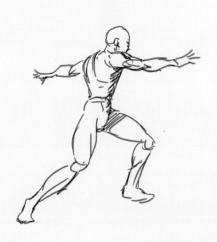

ENERGY TRANSFER WITHIN OBJECTS

Anything attached to a figure undergoing energy transfer (either outgoing or incoming) will also show that transfer taking place. Artists make use of this to give a clear indication of movement within their images. So, with a figure in movement, you will also need to show energy transfer in their:

- Hair
- Jewelry
- Belts
- Loose fabrics such as a cloak
- Any fair maidens they may have slung over their shoulder at the time

RECEIVING ENERGY

Incoming energy transfer is, of course, the opposite of outgoing energy transfer. This may seem obvious, but if you didn't consider this basic principle when depicting an action scene, the characters would have no dynamic quality and would be static. The overall image would have no life or movement. Consider these simple rules when mapping out your action scene.

Here, the energy has not been dissipated by the shield, but has hit the combatant (now very much a victim) and much of the force has been transferred into his body.

So why are the limbs of the figure pointing in the opposite direction to that of the spear? This is because the spear is still traveling forward and the body is being dragged along with it, leaving the limbs flailing loosely behind.

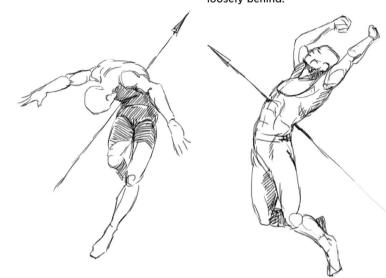

INCOMING ENERGY

1 The figure here is awaiting the imminent arrival of the spear. It has adopted a firm stance with a low center of gravity in anticipation of the incoming projectile.

2 At the point of impact the figure is preparing for the output of energy, but that has yet to happen. The body is braced and with the flow of energy inward and directed into the ground. The shoulders are hunched and the head is bowed as the character "centers" the energy flow.

3 As the projectile hits, we see the energy transfer in the SAME direction as that in which it was traveling. Here, the energy has traveled into the figure. The left arm has been flung in the onward direction of the spear. The torso has also absorbed energy and the legs are flailing behind. Although the main force of the energy has been dissipated by the shield, there has still been enough to knock the figure off balance.

4 As the spear hits, we can see the transference of energy take place. We can see from the figure's pose that the energy left in the spear after its flight is now transferred through the shield and forward into the body. But the shield has absorbed most of the energy in the impact and dissipated it outward in a wide arc away from the figure. After the throw the body will lurch forward, but without the pent-up tension of before the throw.

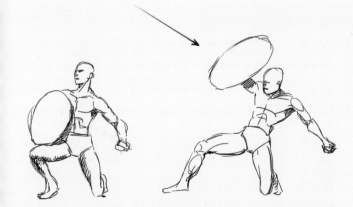

Humankind has a rich and varied history of developing imaginative and inventive tools for killing, and the gory subject holds a perverse fascination for all cultures to this day. But don't be limited to what has gone before—take ideas from history and add new twists to them.

DIRECTORY: WEAPONS

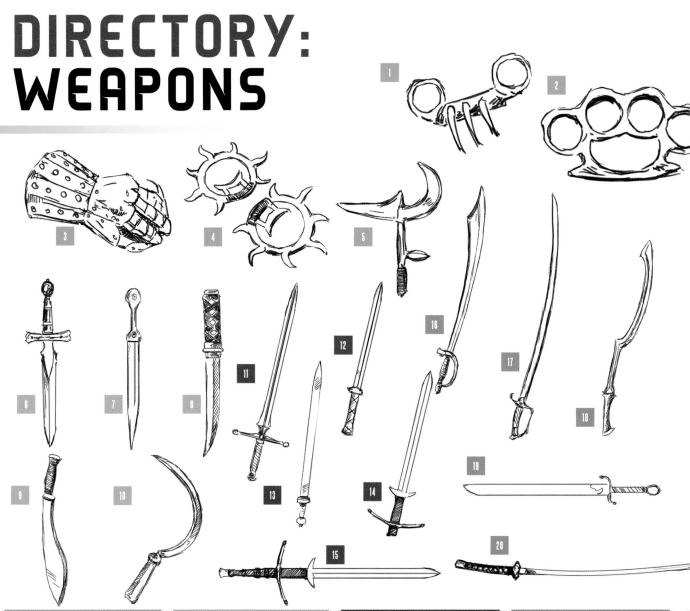

Hand and fist weapons	Short swords and daggers	Straight swords	Curved swords
1 Tiger claw (India)	6 Celtic dagger (Europe)	11 European war sword: One-handed	16 Cutlass: One-handed (Europe)
2 Knuckleduster (Europe)	7 Cossack dagger/Kinjal (Caucasus)	12 Jian: One-handed (Chinese)	17 Saber: One-handed (Europe)
3 Gauntlets (Europe)	8 Aikuchi: Curved short sword (Japan)	13 Spatha: One-handed (Mediterranean)	18 Khopesh: One-handed (Middle East)
4 Wind and fire wheels (China)	9 Machete/kukri knife (Asia)	14 Longsword: Two-handed (Europe)	19 Nandao: Two-handed (China)
5 Fighting bracelets or bladed disks (Africa)	10 Sickle (Global)	15 Claymore: Two-handed (Europe)	20 Tachi: Two-handed (Japan)

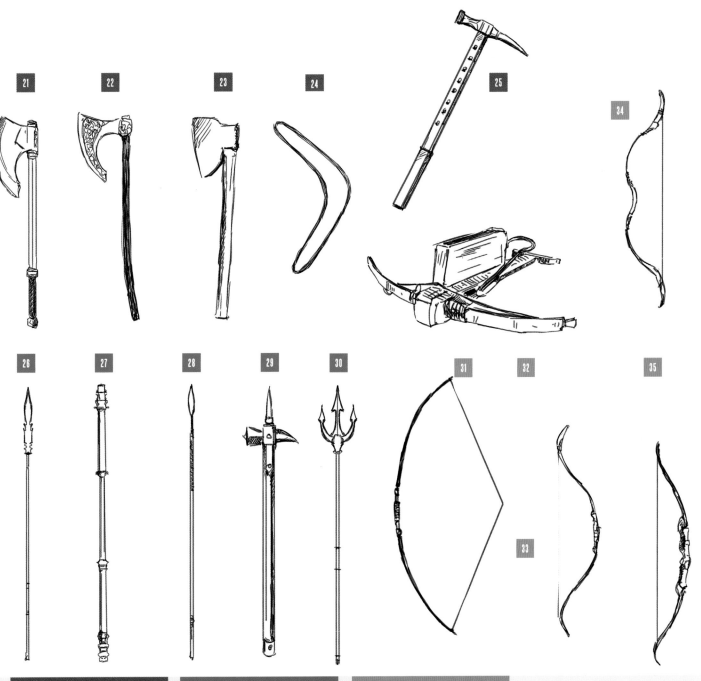

Axs and clubs

21 Battle ax (Europe)
22 Danish ax/Viking ax
 (Europe)
23 Ono (Japan)
24 Boomerang (Australia)
25 War hammer (Europe)

Spears, pikes, and pole arms

26 Lance (Europe)
27 Quarterstaff (Europe)
28 Assegai (Africa)
29 Lucerne hammer (France)
30 Trident (Mediterranean)

Bows

31 Longbow (Europe)
32 Hungarian bow (Europe)
33 Repeating crossbow
 (China)
34 Turkish bow (Middle East)
35 Decurve bow (Europe)

Most of the armor seen in fantasy combat has its origins in the traditional forms of manufacture and can be divided into three basic types: Leather, scale, and plate.

ARMOR

Leather is the oldest kind of protection in battle and was developed when early civilizations learned they could dry out and wear the skins of animals that had been killed for food. Over time they developed methods for strengthening the leather with waxes and lacquers.

Scale armor consisted of hundreds of small pieces of metal, shells, or leather sewn onto undergarments made from leather or cloth. Lamellar armor was very similar to scale armor, except that the pieces were tied to each other and did not require the use of an undergarment.

Plate armor became possible with the development of the smelting techniques that allowed blacksmiths to work with larger pieces of metal and bend them into a variety of shapes that could be fitted to the body. Chain mail was developed soon after, and provided a highly flexible material made of thousands of tiny metal rings linked together.

Traditional styles of armor form the basis of fantasy armor, but it's important that you don't feel constrained by historical reality. When designing your own armor, start with a basic look and then add a variety of elaborate extras to make your characters look as fearsome as possible. You need not necessarily consider the practical implications of the armor your combatants are wearing when adding dragon spines, unicorn horns, and behemoth tusks to your marvelous and magical creations.

▲ ◄ ARMOR ADAPTIONS

You can use traditional armor to convey the solidity and dependability of your character (above, image by Matt Stawicki). Or you can use it as a base to add decorations and embellishments, for example elegant scrollwork and gruesome-looking spikes (left, image by Nikolay Yeliseyev).

DISTINGUISHING ARMOR

Nikolay Yeliseyev has made key distinctions between the characters' armor to differentiate between them, and several interesting twists have been added.

The black-armored character:
Wears an animal jawbone over his shoulder (1).
Has animal teeth and bones around the wrists and helmet, and animal claws on the gauntlet (2).
Is daubed with purple face paint (3).

The white-armored character:
Has elaborate scroll designs on the plate armor (4).
Wears a complex bird-like boot, complete with a feminine heel (5).
Has well thought out belts, buckles, cords, and rivets (6).

ELABORATION

Once you've developed your basic armor, consider adding ornamentation to give your characters an individual look and help identify opposing armies. You can add a variety of elements such as:
• Bones and horns
• Teeth, tusks, and spines
• Fur, hair, and feathers
• Face paint, tattoos, and piercings

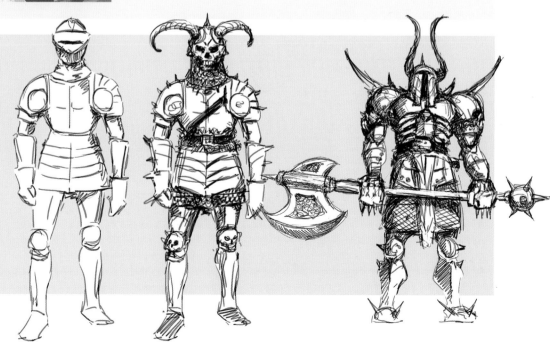

Armor and accessories are functional and decorative—use them to tell the viewer about the character's personality, background, and setting.

DIRECTORY:
ARMOR AND ACCESSORIES

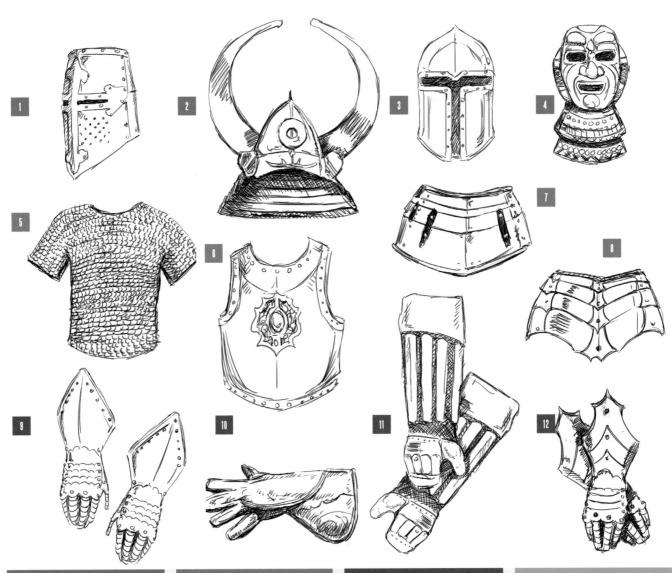

Helmets	Body armor	Hands and Arms	Scale and mail
1 Great helm (cylinder helmet)	5 Hauberk (chain mail shirt)	9 Gauntlets	13 Scale armor and/or lamellar armor
2 Kabuto (samurai helmet)	6 Cuirass (breast armor)	10 Falconry gauntlets (leather)	14 Japanese woven leather armor
3 Barbute (with T-slit)	7 Faulds (waist protection)	11 Kote gauntlets (samurai)	15 Modern buckled leather chestplate
4 Mengu (Japanese face mask)	8 Fantasy faulds	12 Fantasy gauntlets	16 Fantasy winged armor

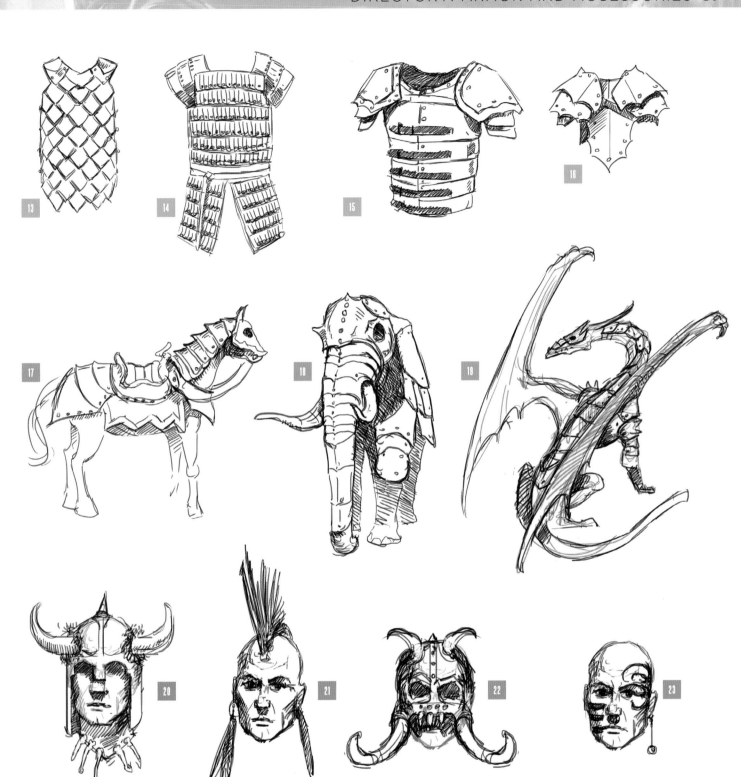

Animal armor

17 Horse armor
18 Elephant armor
19 Dragon armor

Ornamentation

20 Bones and horns
21 Fur, hair, and feathers
22 Teeth, tusks, and spines
23 Face paint, tattoos,
 and piercings

Two-handed combat is used when the combatant is carrying a large weapon. Many traditional forms of sword and ax fighting necessitate this practice.

TWO-HANDED COMBAT

The use of longswords and claymores requires a specific set of moves and stances to enable the combatant to wield these massive and heavy weapons. This method tends to be of particular use in fantasy combat art, as it allows the artists to design a range of oversized weapons that can add impact to the illustration.

The use of a longsword allows for greater reach in battle, which gives an advantage against a foe with a shorter sword. This would be ideal for killing dwarves (whose diminutive stature doesn't allow for the use of longswords) or for fighting dragons (whose enormous body size requires a good deep plunge in order to get to their evil black hearts)!

When depicting two-handed combat, give special consideration to the anatomical effect of having both arms close to the body, as well as the need for the figure to counterbalance the weight of the weapon.

DOUBLE-HANDED SWORD

Double-handed swords such as claymores, longswords, tachis, and Nandaos generally have long handles that allow for a two-handed grip and are also necessary as a counterbalance to the long blade. Note also that the crossguard on all swords protects the hands as well as stopping other weapons from sliding down the blade and slicing off the fingers. A standing pose such as this requires a solid footing; a long weapon can easily cause imbalance in the figure (1).

SPEAR: ATTACK

Although a spear is thrown with one hand, a two-handed grip with a spear, halberd, pike, or ax comes in useful when delivering a fatal blow using a plunging thrust. Poses such as this require some attention to get the exact layout of the arms correct and you may wish to use a mirror at home to study more closely the exact

positioning. It's unlikely you will have the muscles of a warrior, but you can add those later once you have the pose right (2).

SPEAR: DEFENSE

Poses that use two hands placed on a weapon at a distance from each other such as these tend to be defensive, and are ideal for figures using batons or spears in close combat (3).

AX

A double-headed ax can be an interesting variation for a combat situation, and an exaggerated design can lend a dramatic edge to an otherwise basic weapon (4).

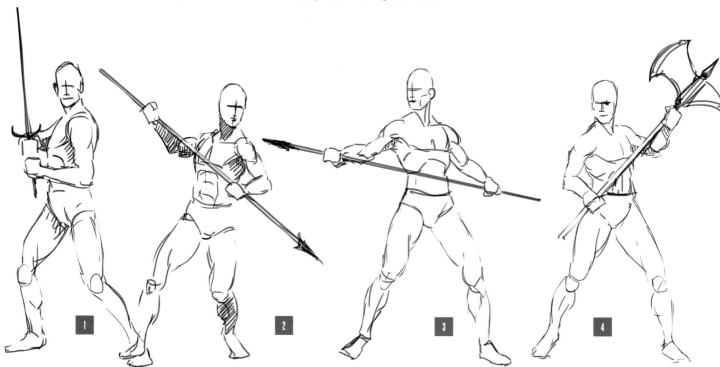

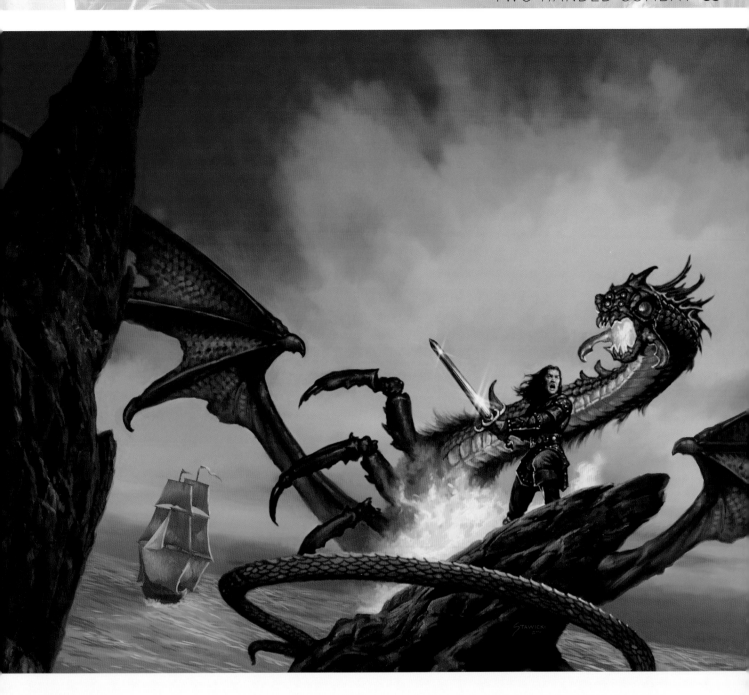

STEADY GRIP

The compositional power of this image by Matt Stawicki is in the solid stance of the hero in contrast to the daunting threat of the dragon that coils around the outcrop on which he is standing.

The hero's pose suggests fearlessness, and this is further enhanced by the steady two-handed grip he has on his sword (1).

The sword is heavy and well built—a reliable tool for the task ahead (2).

Attention is drawn to the weapon itself by the addition of multiple highlights on its blade. Spots of reflected light on the brass or gold ornaments on the hero's tunic also help draw the eye to him (3).

The scene is depicted from a low angle, so we appear to be looking upward. This allows for the hero to be depicted looking noble and the dragon to loom above us, outlined against the sky and emphasizing its scale (4).

When in doubt, use magic. Supernatural powers, spells, firebolts, and elemental forces are guaranteed to add spice and visual expression to your combat scene, and a good old-fashioned slaughter-fest can always be enhanced with the addition of some dazzling magical effects.

MAGIC AS A WEAPON

The use of magical forces can take an infinite number of forms, any of which will affect the content and composition of your battle scene.

Lightning-type charges, smoke effects, fireballs, and a myriad of colorful effects are used by wizards and warlocks alike to give themselves an advantage in any fight.

The introduction of intangible beings such as wraiths, ghosts, or hordes of undead can have a distinctly tangible affect on the poor adventurer who incurs their wrath. The description "hard to kill" is an understatement where these creatures are concerned, so you may want to equip your hero with a sword of elven make to give him or her a fighting chance.

Invisible magic can be brought into play to control objects—for example, by bringing a ceiling down on one's foe with a mere gesture or using mind control to confuse them. You might even want to try twisting the very fabric of reality itself or open up a portal to another dimension into which the hapless victim is thrown.

ELECTRICAL ENERGY

SUBTLE MAGIC

In this image by John McCambridge, magic has been used in a very subtle way to do two things that make it distinctive:

The sorcery glows on the woman's hand as she prepares for the strike. The artist has used this to highlight her body, making her stand out in the composition. The magic also creates a spread of warm light across the surface of the water.

It may seem that there is a lack of action, but the image tells a powerful story and raises interesting questions for the viewer: Why are these people about to fight? What is she that she has such powers? Why does she have spines on her shoulders? What is the meaning of the carving on the standing stone? All of these subtle elements contribute to the atmosphere and draw us into the magic of the image.

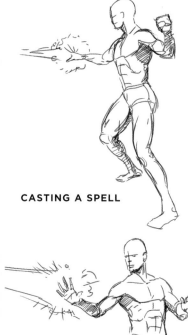

CASTING A SPELL

CONJURING

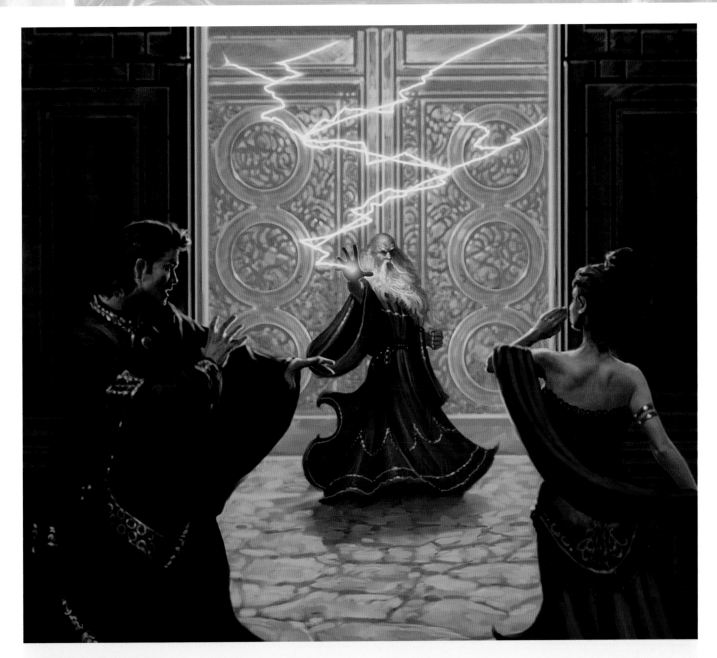

DAZZLING DESIGN

Where there are wizards there is usually magic, but any character can be blessed with supernatural powers. You can use lightning bolt-style magical effects to enhance your composition, as here by Matt Stawicki.

In this case the magic spell is shown as a spiky lightning bolt that spreads out as it comes toward us, helping to create depth of field (1).

The wizard stands with his active arm pushing forward, emphasizing the outward thrust of the spell (2).

The doorway frames the action. Outside of this everything is in shadow, which has the effect of drawing the eye to the center of the image (3).

The male and female figures are obviously the target of the wizard's wrath (maybe they forgot his birthday), and their poses are defensive (4).

Note that there are strong highlights along the inside edges of the victims' faces and bodies that have been created by the light from the magic spell (5).

BATTLE CHOREOGRAPHY

Epic battle scenes are, perhaps, the most labor-intensive undertaking of any fantasy scenario. Such images require a great many figures, many of which will need to be executed in detail. Complicated action and anatomy poses are usually necessary, as well as some indication of architecture and landscape. You will likely want to include dazzling effects and no small amount of bloodshed, all of which you will want to depict in convincing tones of light and shade, and possibly technicolor brilliance.

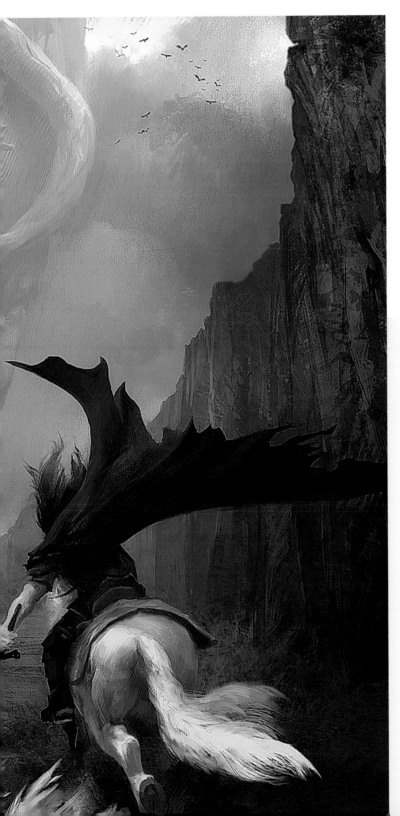

Planning your epic battle scene is much like planning a military campaign. First of all you must consider the material aspects.

Where is the battle set and how will this affect the action (see Chapter 4, Genres)? The conditions may be hot or cold, wet or dry, and these factors and others will influence what your characters are wearing and how they interact.

Is this a humanoid versus humanoid scene? Or is it man versus beast, or beast versus beast?

What are they fighting for? You must have a reason for your battle, so it's good to have some idea of the events that led up to the scene. Are they fighting to release a captive maiden—or is that apparently innocent maiden an evil sorceress who has turned brother against brother?

What kind of weapons will be used? How technologically advanced will they be? Will the combatants be earthbound or have the power of flight?

CREATING DRAMA

In *Dark Future* by Daniel Ljunggren we see not the battle itself but the anticipation of battle, the atmosphere drenched in impending evil. It is the future action that lends this image its drama.

The horse's sweeping white tail is echoed in the distance by the fluttering banners of the army amassed in the distance (1).
The sweep of the hero's red cloak directs the viewer's eye into the center of the picture and the action (2).
The behemoth, so vast that it is cropped at the top of the frame for effect, has us marveling at the fearlessness of the hero—or perhaps his folly (3).
The cliffs that trap the hero on both sides create a sense of claustrophobia (4).

A battle scene might take a while to create, so you may want to start off with something more modest. Consider a composition that takes you close in to the action before you tackle a sweeping vista with a cast of thousands. Just ask yourself how patient you are. You will find that as time passes you will build up stamina as an artist and can execute more elaborate and demanding ideas. So don't be put off—it will only be a matter of time before you can handle a scene like the battle of Minas Tirith in *Return of the King*.

WORK STEP BY STEP

Take the time to address your work in stages. These stages are part of the process that almost every artist goes through to a greater or lesser degree. Some artists absorb themselves more in research before commencing any drawing, while others will pull together inspiration as they dive into the final piece.

1 Research the content of your artwork. This will include costume, architecture, monsters, and even landscapes and skies. Looking for ideas for things contained in your image will inspire you and add layers of meaning to the concept.

2 Working in your sketchbook, rough out the general idea of your scene. These sketches should capture the initial spark that made you want to create this image in the first place.

It's helpful to try a few different ways of staging your fight. It's always best to do roughs of several possibilities before committing to a final layout, as your ideas will always improve as you work through them. This is all part of the process.

Consider what your characters are doing first, then push the limits of their action—for example, by emphasizing their poses. Next, start working on ideas for the background.

3 This stage is where the most intensive creative work takes place as you take care of every detail of the artwork. It is here that you can take the time to ensure you are entirely satisfied with every aspect of your piece, from the proportions of the figures to the balance of light and shadow.

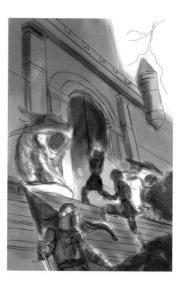

4 The final execution of the artwork differs from the pencil stage in that you will no longer be thinking so intensively about ideas and details, but concentrating on getting into a steady working rhythm. The stages will be the same whether you are working digitally, in paint, or pen and ink. Begin by "blocking out," that is, laying down the main outlines and areas of color, including the main areas of light and shadow.

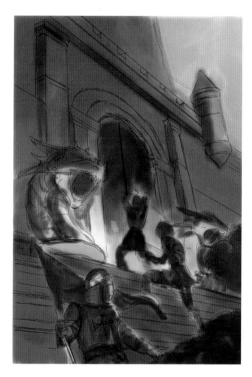

5 The blocking out stage will give you the background layer onto which you will build up detail. You can work in a series of sweeps, each time adding more detail and light and shadow. Each successive sweep across the painting will be an entire session. A good analogy for this would be plate spinning—attending to one area of the painting, then moving across and bringing another area up to the same degree of finish, so that every aspect of the artwork is considered in equal measure to every other.

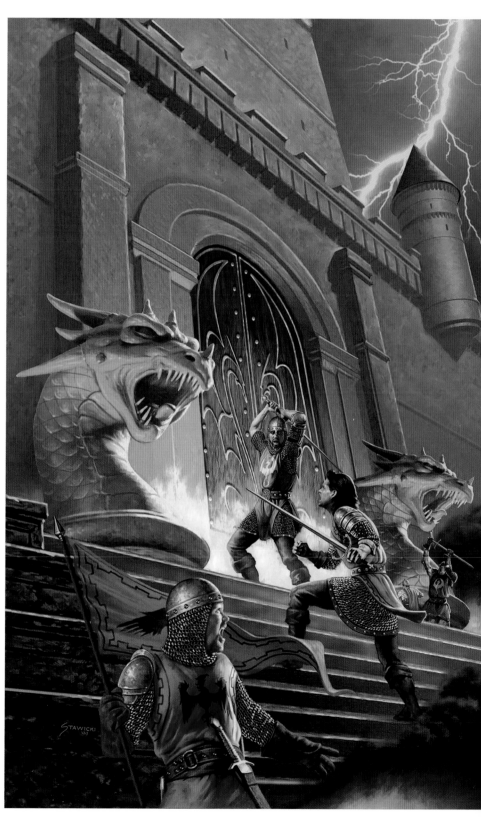

6 The final stage of the process requires fine-tuning, as you add the darkest shadows, the brightest highlights, and the intricacies of ornament, hair and skin, smoke, fire, and blood. This part of the process can take a long time, and many artists keep returning to make improvements to their work for weeks or months, and in some particularly epic cases, years.

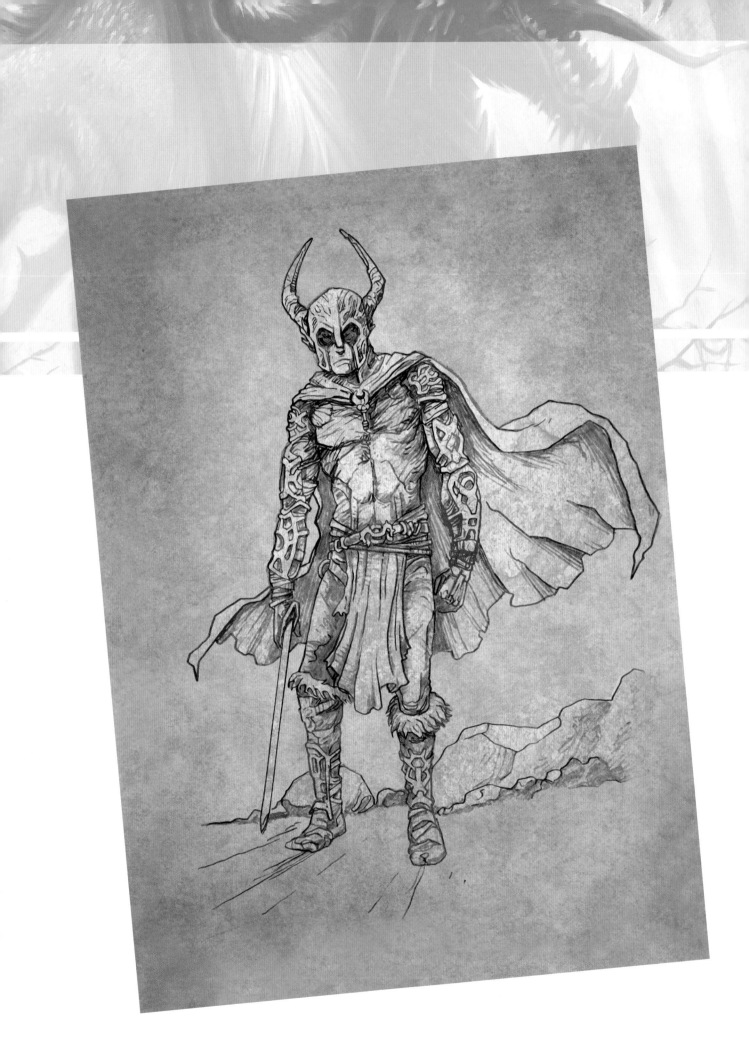

FANTASY GENRES

4

"The world of the imagination is eternal... and infinite."

William Blake (1757–1827)

The only limits we truly have are the limits of our own imagination. In choosing a setting for our fantasy conflicts and epic struggles, we could place our characters in cities built of living flesh, where our warriors do battle with killer fruits, or we could have our heroes and heroines confront origami villains made of rice paper, or live in dimensions where time moves backward... Every once in a while an artist or writer will emerge with a truly original vision—a paradigm shift that captures the spirit of the times and produces a new genre in fantasy art and fiction.

FANTASY WORLDS

But most of us will usually return to the same tried and tested locations, characters, and materials that have populated the worlds of fantasy since time immemorial. And we do this with good reason too; it is a matter of symbolism.

THE MONOMYTH

Joseph Campbell, possibly the greatest of twentieth century "mythographers," wrote a book in the 1940s called *The Hero with a Thousand Faces* in which he put forward the theory of the "monomyth," which suggests that all heroic quests and stories are fundamentally the same and follow the same pattern in terms of their symbolism. That symbolism represents emotional, social, and cultural patterns that are embedded deep within the psyche of all human beings. He theorized that we are drawn to the same basic ideas and stories, characters, places, and events because they somehow reflect the trials and tribulations of our everyday lives, no matter how mundane they seem. Basically, Campbell pointed out that we emotionally connect with a hero's quest because it helps us to navigate our way through our own lives, even if it is something as seemingly mundane as seeking employment or tackling a tough exam.

Campbell's book was a sensation. Over the years it has exerted a huge influence on the output of the American movie industry and it has been used as the template for scriptwriters and novelists the world over ever since.

But Campbell's influence has had mixed results, with the majority of writers choosing to reduce his vision to its basics, resulting in the repetition of the same old scenes and settings over and over. We've all seen it, an epic new movie, full of sound and fury but somehow leaving us feeling unfulfilled. We've seen it all before and despite having all the classic elements which we love, the movie or book has not brought anything new to our experience of the genre and has left us with little in the way of inspiration that we can apply to our own lives.

◄ MIXING GENRES

Although the hero here appears to be a knight, Nikolay Yeliseyev has added a twist to the genre by having him battle a robot-like foe— classic fantasy meets science fiction.

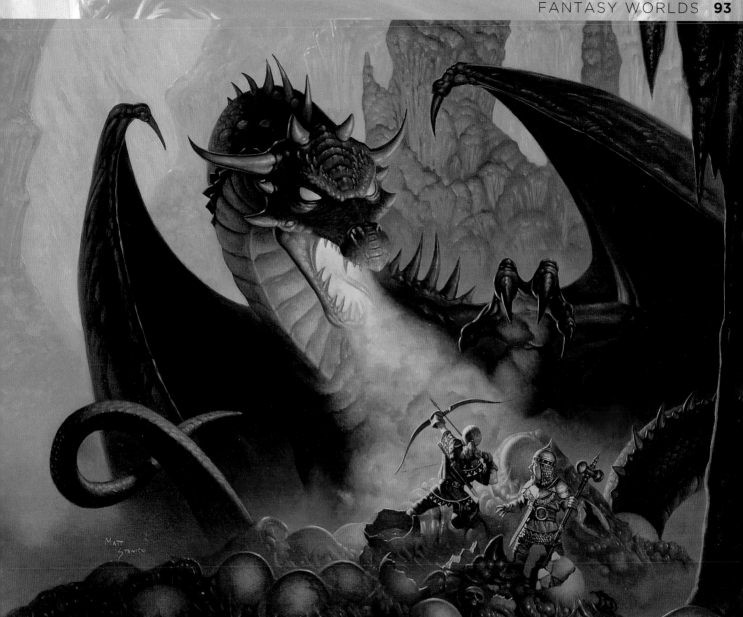

The challenge for you, the fantasy artist, is not only to gain a thorough understanding of all the classic, eternal genres of fantasy combat, but also to push your imagination and add a new ingredient, a subtle twist, a small wrinkle, that will somehow bring something new to this field.

A ROUGH GUIDE TO GENRES

The following pages provide a rough guide to some of the most popular fantasy genres. These all overlap—as they should—and they can continue to be subdivided and analyzed into infinity. But the main purpose here is not to define fantasy but to create it. So let's not get hung up on the definitions and throw the whole bunch into one big mixing bowl and see if we can find some new ingredients to spice it up.

▲ ARCHETYPES

The classic archetype of the hero, his dwarf sidekick, and the dragon defending its nest resonates deeply across the centuries and continues to inspire artists today, such as in this image by Matt Stawicki.

MIX IT UP

Always try to add something new to your fantasy setting, something unexpected that will surprise people. But don't add too much too soon—exciting new ideas should be added to the mix like rare spices, allowing the new flavors to come through slowly.

High fantasy is the classic fantasy genre of Tolkien, Le Guin, and C. S. Lewis, but it may also include historical, paranormal, and medieval fantasy, as the archetypes tend to be very similar.

PLEASANT LANDS

BASIC WEAPONS, SUCH AS A MORNING STAR AND A SIMPLE SWORD, ARE BEST FOR HIGH FANTASY SCENES.

This genre usually includes the same basic elements:
• An alternative world that closely resembles Europe in the Middle Ages (detailed maps are usually provided).
• A storyline that deals with clearly defined "good" and "evil." Good is always good, evil is always evil and there's not much room for speculation (basically, it's the ten commandments).
• Classic character archetypes such as heroes, heroines, dark lords, etc.
• Mentors such as wizards, goddesses, and witches, who offer advice and support.
• A host of paranormal beings, ranging from dwarves to fairies and beyond.
• Monsters—lots and lots of monsters, the bigger the better.

Stories and artworks in this genre will show a quest and various challenges that will take the audience through a wide variety of familiar landscapes from the rolling hills and meadows of Oxfordshire in England that inspired Tolkien's "Shire" and Lewis Carroll's *Alice's Adventures in Wonderland*, to the breathtaking mountain scenery of the Harz Mountains in Germany that inspire legends of the dwarf kingdoms, through to the deep, dark forests of northern Europe that gave birth to the Norse myths.

These are the places where civilization has found a foothold, a place where peace is likely to reign and give us something for the bad guys to threaten. Here you will find a basic infrastructure: roads and canals that lead from farms and forests to towns and cities. There will be trade and wealth supported by laws and government.

▲ WEAPONS

High fantasy weapons are not technologically advanced. Draw upon a vast and fascinating history of real world historical weapons for reference, such as The British Royal Armouries' online collections. Learn about how the weapons were made and used so that you can develop your own designs.

CHECK THESE OUT

A good place to start is J. R. R. Tolkien's trilogy, *The Lord of The Rings*. Early masterpieces include Mallory's *Morte D'Arthur* and the *Volsunga* saga, which, along with the Celtic and Norse myths, formed the template for all fantasy legends to come. These gave us the classic motifs of muscular heroes vanquishing dragons and chasing after magical rings. Modern entrants in the genre would include *Game of Thrones* by George R. R. Martin (who possibly thought that adding "R. R." to his name would liken him to Tolkien) and then, of course, there's Ursula K. Le Guin's *Earthsea* books and J. K. Rowling's *Harry Potter* series.

Doune Castle was used as the set for Winterfell in the television series *Game of Thrones* (2011–present).

► **NATURAL WORLD**

Rolling hills, fields of green, emerald oceans... While England and Ireland provide some of the archetypal landscapes for fantasy art, New Zealand has become the location of choice since the *Lord of the Rings* movies. Don't forget flora and fauna. Fill your landscapes with improbable details such as the giant sequoias of California or the brilliant orchids of the South American jungles.

EXAGGERATE THE PROPORTIONS AND FEATURES OF YOUR REFERENCE CASTLE TO MAKE THEM MORE FANTASTIC.

LAYER YOUR CHARACTER WITH FUR, CLOTH, AND METAL FOR A MULTI-DIMENSIONAL CHARACTER.

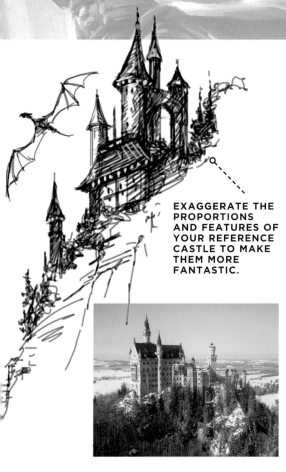

THIS DRAGON HAS FOUND THE PERFECT DESERT PERCH TO GUARD HIS TERRITORY.

▲ **ARCHITECTURE**

The basic reference for high fantasy architecture is historical. Look at the hilltop towns of Italy (such as Sarnano in Le Marche) for superb details of small medieval towns. For timber-constructed houses, check out English Tudor architecture. Add a spin to your designs by researching old wooden houses in Karelia. Good castle design is a must, so check out fairytale castles in Germany's Black Forest, of which Neuschwanstein Castle is the best known.

▲ **CLOTHING**

Clothing is generally made of cloth, metal, or leather. The rich will wear brightly colored silks and embroidered cottons, whereas the poor will wear dun-colored rough wool. For armor you can refer to huge online resources. Leather is also heavily used with armor and you can build and elaborate on the basic Western medieval designs by looking at interesting elements from other continents, such as Asia and South America.

► **PALETTE**

Seek out stunning photographs of skies, mountains, plains, and forests. Check out glaciers in the arctic, jungles in the tropics, and vast plains and mountain ranges in India and Africa. Exaggerate dimensions and distances to add a huge scale to your artwork. Remember, high fantasy is epic fantasy, so push everything to the limits of your imagination. You have no excuses for limiting yourself to a mundane palette of colors and locations.

► **TRANSPORTATION**

The high fantasy genre doesn't use engines but relies on human- or creature-powered vehicles. Seek out interesting historical modes of transportation but elaborate on them: make them bigger or smaller; add wheels or take them away; and invent strange and wonderful beasts to propel them. Mix up your materials. For example, take a modern combat tank and redesign it to be made out of wood and canvas. Don't limit yourself to 3D models downloaded from the internet; take the time and make the effort to build on these basic models to make something exciting and original.

A GIANT PROPELS A RUDIMENTARY TANK.

The dark realms of high fantasy are the necessary flip side to the green shires and woodlands of the genre, and it is here that your most desperate conflicts are likely to be played out. Such is the appeal of these sinister regions that it has spawned its own genre with the likes of Clive Barker's *Weaveworld* and Peter Straub's *Shadowland.*

DARK REALMS

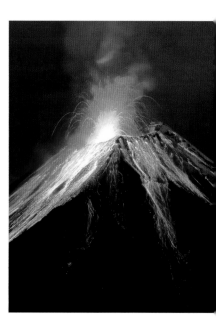

THESE WEAPONS ARE DANGEROUS FROM ALL ANGLES AND ENSURE DAMAGE TO ENEMIES.

This is the place where it all goes wrong for our heroes and heroines and any fantasy artist will be itching to try their hand at depicting sinister castles wreathed in clouds and gloomy kingdoms buried deep in the bowels of icy mountains.

The main reference for the darker places is the medieval gothic architecture seen in churches and castles around Europe. It was this style that inspired Horace Walpole to write the first definitive work of Gothic fiction some centuries later in 1764. His book, *The Castle of Otranto*, sparked a fashion for the Gothic revival in the decorative arts and architecture, which continued into the nineteenth century, which in turn influenced the gothic style that fantasy artists use today.

Painting the dark realms requires a lot of attention to shadow and a good understanding of the contrast between light and dark, because showing complex battle scenes in underlit locations can be quite a challenge. You'll need to look at highly detailed gothic architecture and pay a lot of attention to volcanic rock formations, along with extreme elemental conditions such as ice, snow, wind, and fire.

▲ WEAPONS

The weapons of the dark side of the genre will often be more elaborate than those wielded by the heroes. Look at armor from Asia and India for some strange and wonderful weapons of destruction. Consider adding multiple blades, sharpened cogs, and florid ornamentation to spice up your designs.

▼ NATURAL WORLD

Volcanoes are a great place to start when looking for a dramatic location. Additional sources of inspiration are extreme weather conditions, such as blizzards. Consider placing your action against natural events such as earthquakes, floods, or avalanches for additional drama.

VOLCANOES PROVIDE AN INSTANTLY THREATENING AND DRAMATIC SETTING.

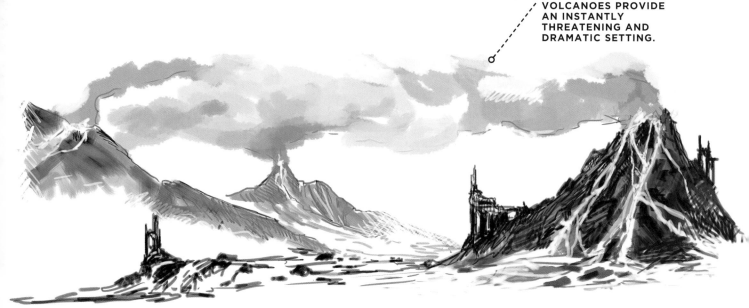

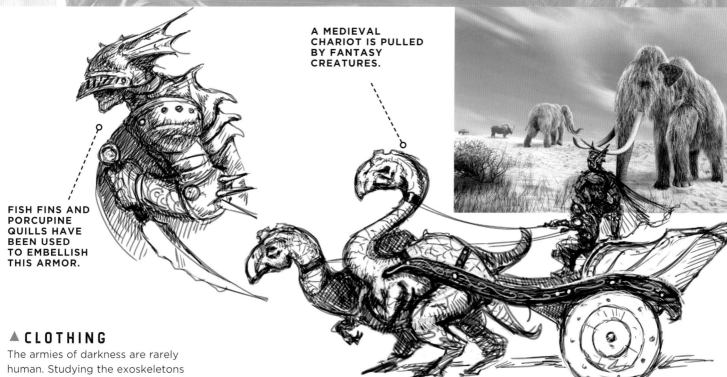

A MEDIEVAL CHARIOT IS PULLED BY FANTASY CREATURES.

FISH FINS AND PORCUPINE QUILLS HAVE BEEN USED TO EMBELLISH THIS ARMOR.

▲ CLOTHING

The armies of darkness are rarely human. Studying the exoskeletons of insects, fish skeletons, or animal skulls may give rise to interesting ideas for clothing. For decoration, consider looking at bird feathers, which were used by Inca and Mayan warriors in their battle dress. The armor of lower order soldiers often appears handmade, constructed from a mix of animal skins and roughly beaten metal and leather. Add tribal markings and paint daubs to provide a striking and fearsome symbolism.

▲ TRANSPORTATION

Consider the landscape in which your vehicles will operate to give credibility to your creations. For example, a snowy, icy landscape may give rise to a vehicle with skis pulled by wooly mammoth-like creatures, whereas a desert environment may require a vehicle with caterpillar tracks. Also consider recent developments in transportation, such as paragliding and windsurfing, and reverse engineer them to suit a more ancient time period. You also have the option of designing any number of fantasy creatures to carry your armies. The Norse god Odin rode an eight-legged horse, Freya rode in a chariot pulled by white cats, and the original Valkyries rode huge flying wolves.

▶ PALETTE

Look at photographs of storms and hurricanes to develop a range of colors, including dazzling purples and crimson reds with flashes of vibrant yellow and burning orange to add contrast.

CHECK THESE OUT

Dark fantasy art is as old as the myths that inspired it, and the medieval/Renaissance works of Hieronymous Bosch (right) and Vittore Carpaccio are worth studying.

Classic paintings such as John Henry Fuseli's *The Nightmare* and Arnold Bocklin's *Island of the Dead* were a huge influence on the genre, and are worth studying to understand the symbolism and see why they have such an effect, even today.

Spanish master Francisco Goya innocently knocked out a painting called *Witches' Sabbath* in 1820, which got him a bad name with the Church at the time, and in doing so sowed the seed of fantasy gothic art.

But art of this type really came into its own during late nineteenth century, along with the morbid love of death that suffused that period. Check out Highgate Cemetery in London, England, for some moody details, and the work of the Pre-Raphaelite artists such as John Millais Everett, whose painting of Ophelia helped to kickstart the genre—and also nearly resulted in the death of his model Elizabeth Siddal, who spent many hours posing in a freezing bath.

The retro genre of fantasy art includes steampunk, gaslamp, engine punk, and many other variations, all of which incorporate industrial and scientific elements. These genres draw inspiration from the nineteenth century and the Wild West.

SATANIC MILLS

INCORPORATE SATANIC ELEMENTS SUCH AS HORNS AND SKULLS INTO YOUR ARCHITECTURE.

The most notable element of these stories is that they include steam- and petroleum-powered technologies, and images of science working alongside supernatural powers and fantastic beings.

It's healthy for any artist to blur the distinctions between any of these genres—even the World of Warcraft and The Elder Scrolls have technological societies that could be described as steampunk—so you can also be thinking about mixing any time period into your classic fantasy settings. For example, you could look at the Russian Revolution or eighteenth-century China, Georgian London, or 1950s America to come up with fresh new variations. Wuxia is a Chinese subgenre of fantasy and martial arts, which focuses on kung fu and a tradition of swordsmanship and honor similar to Japan's Bushido and Europe's chivalric traditions. It is useful when designing fantasy combat to study a variety of martial traditions and mix and match various elements from them.

Genres such as low fantasy and hard fantasy set their stories in a rational, knowable reality. Some stories may avoid the use of classic fantasy elements such as dragons and elves, but others will include them while building in a believable reason for their existence. The challenge is to design a world that could actually work in real life, with machines, weapons, and transportation that it might be possible to build.

▲ ARCHITECTURE

Architectural styles can range from the fantasy elements of the Gothic revival to the dark, satanic mills of the industrial revolution, featuring mighty factories with gigantic chimneys, which can mix nicely with the fairytale towers and spires of classic castles and cathedrals.

THIS LOVELY PLANT HAS A DEADLY APPETITE.

◀ NATURAL WORLD

The natural world in these fantasy genres tends to focus on highly industrialized societies where nature is fighting to survive, or indeed, is fighting back. You may wish to consider a setting in which the manmade world is at odds with nature, which is evolving to become the enemy of man, with deadly jungles, poisonous plants, and animals that have adapted to confront mankind's destructive creations.

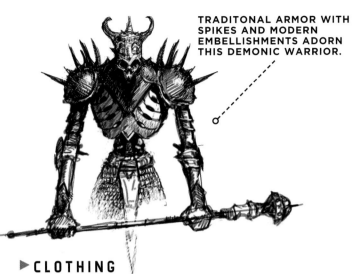

TRADITONAL ARMOR WITH SPIKES AND MODERN EMBELLISHMENTS ADORN THIS DEMONIC WARRIOR.

▶CLOTHING

You don't have to limit yourself to nineteenth-century hooped dresses, high-buttoned coats, and stiff-necked uniforms. You may wish to work with a traditional high fantasy look of robes and tunics, but simply add an interesting twist from any period in history (or your imagination) such as a long, buttoned duster coat, a wide-brimmed hat, or an armored exoskeleton.

A DRAGON SCALE IS USED AS A SHIELD.

◀WEAPONS

No longer limited to swords, shields, axs, and various other pointy things, you can let your imagination fly and conjure up crazy combinations of guns, hammers, tanks, or trebuchets, creating a bizarre mix of medieval machines and industrial technologies. To the traditional materials of iron and bronze you can add brass and steel.

▶PALETTE

The palette for realism naturally requires lots of brassy gold and shimmering glass, along with distressed finishes such as rust and decayed metal.

▶TRANSPORTATION

Old ports, shipping yards, railroad stations, and factories of the industrial and modern ages make good reference points for your transportation needs. You will be looking at levers, dials and gauges, pistons, propellers, and chain-driven machines of all types. You may want to cross these items over with swords, scabbards, pikes, and battleaxs to produce some bizarre hybrids. You can also look at sailboats and balloon-driven aircraft such as zeppelins and airships.

A STEAMPUNK ZEPPELIN SOARS PAST A FUTURISTIC CITYSCAPE.

The elemental world is not a fantasy genre in its own right, but applies to all genres. We need to shake things up a bit to avoid falling into clichés and stereotypes. One of the key tricks for creating a suitable setting for your combat scenes is to consider the various elemental qualities that will be included.

BATTLING THE ELEMENTS

To begin, you need to choose some basic landscapes from, for example, jungle, forest, savanna, ice, water, earth and rocks, air, and so on. To these background settings you will add more transient weather elements such as fire, storms, wind, snow, and blazing heat. At this point you can start to ask questions about mixing these features. For example, you could have a landscape of rock islands floating in the sky to which you might decide to add a jungle or arctic theme. You could push the limits of plausibility further by setting your action in ice castles ringed by seas of lava.

Then you may wish to add further tweaks to your settings: Rather than have a city floating on water, perhaps it could be set in a sea of toxic gas, in which case anything beneath a certain level gets killed. This would then affect the combat action, with each side attempting to push the other downward. Alternatively, the sky might be made of fire. In this case the opposite would happen, and the action would consist of attempts to push the enemy upward.

This is all to show that the elemental conditions you choose will affect the action itself. In the goblin kingdom scenes in *The Hobbit*, the inner mountain setting affected the nature of the action. Mixing and matching various environmental landscapes and then setting specific environmental conditions will lead you to use your imagination to devise ingenious action scenes.

A MOUNTAIN HAS TURNED INTO A ROCK GIANT— A FORMIDABLE OPPONENT.

CHECK THESE OUT

RPGs (role-playing games) and computer games are renowned for coming up with ever more weird and wonderful fantasy settings. These are a good place to see a few examples, but for inspiration of your own just look at our own amazing world (and solar system) and start mixing it up. For example, check out the fantastic limestone pinnacles of the Ankarana National Park in Madagascar, the impressive Puente Del Inca in Argentina, and the stunning rock-carved city of Petra in Jordan (right) and get your creative mojo working overtime.

▲ WEAPONS

The environment itself can be a weapon against us and there are many fantasy movies that utilize this idea. Whether it's jungles with poisonous flowers or intelligent sand dunes that come at you like a tsunami, the natural world is a veritable cornucopia of combat possibilities.

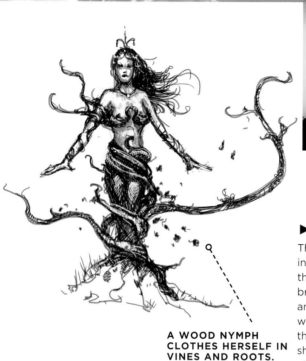

A WOOD NYMPH CLOTHES HERSELF IN VINES AND ROOTS.

►NATURAL WORLD

There is no shortage of inspiration to be found in the natural world, but the breathtaking array of colors, textures, and details may seem overwhelming when it comes to trying to replicate them. The trick is to look for a strong shape or a single idea and use that alone, such as the striking silhouettes of the trees in the photograph above.

▲CLOTHING

Any environmental or natural feature can become humanized. Trees could have minds of their own—both benign and malevolent. Imagine turning any feature into an intelligent life form: rocks clad in mossy clothes, clouds that form into the shapes of monsters or even weapons, and cherry blossoms forming the dress of a wicked river goddess—these are just a few of the infinite number of combinations that could be explored.

THIS TREE IS HOME TO THE DENIZENS OF YOUR FANTASY FOREST.

A WARRIOR RIDES THROUGH THE SKY ON A BOLT OF LIGHTNING.

▲TRANSPORTATION

Elemental forces and natural features lend themselves to interesting transportation possibilities. Imagine streams of rocks that defy gravity, flowing through the air like rivers. You could choose any natural phenomenon, mineral, or gas to use as a means of transporting monsters or supernatural beings. Perhaps devise a place in which mysterious spirits can only travel through water or create a tribe of malevolent beings that can only pass from shadow to shadow.

►PALETTE

Yann Arthus Bertrand's *The Earth from Above* contains enough colors to last you a lifetime. The Hubble space telescope photos have enough to last an eternity. Or look out of your window at sunrise and sunset; sooner or later you will see a depth and range of colors that inspires you.

A post-apocalyptic setting is one in which a great civilization has ended, usually abruptly and in a cataclysmic way such as plague, war, or social collapse. It's not limited to science fiction, as any alternative reality can have its "end of days"—even if it is set in the far distant past.

POST APOCALYPSE

This genre dates back to ancient times and various belief systems ranging from the religion of ancient Babylon to Christianity. All of these have warned of apocalyptic destruction, but post-apocalyptic settings in literature and film became most popular after the Second World War, when the threat of nuclear annihilation made the scenario a distinct possibility.

The genre is appealing because it allows a new tribe or civilization to travel through the ruins of an older one and draw conclusions about what came before. The entire landscape has mystery already built into it, which can help propel a story along and can also add interesting elements to a single fantasy combat image.

► TRANSPORTATION

Post-apocalyptic scenarios usually demand that the technology of the new civilization has evolved from that of the civilization that went before. In Phillip Reeve's *Hungry City Chronicles*, the current civilization has lost digital technology and electronics, but it has developed highly advanced internal combustion engines, which it has used to make entire cities into mobile vehicles. So you can take any two periods of cultural or technological development and replace one with the other.

A CHARACTER CARRYING HIS TOOLS, WEAPONS, AND SUPPLIES WITH HIM.

CHECK THESE OUT

Mary Shelley, the author of *Frankenstein*, wrote what is considered to be the first post-apocalyptic novel in 1826, called *The Last Man*. Recent post-apocalyptic books and movies include *The City of Ember*, *The Book of Eli* (below), *Terminator Salvation*, *I Am Legend*, *Oblivion*, and many more. The video games industry favors post-apocalyptic scenarios, with games such as the *Fall Out* series proving to be hugely popular with fans, while *Lightning Returns: Final Fantasy XIII* features a world in which chaos has infected the flow of time.

▲ CLOTHING

Post-apocalyptic societies tend to be scavenger cultures, so they provide a great opportunity for putting together costumes made from found objects; for example, a colander might become a helmet. People are likely to be nomadic and carry a lot of survival gear with them, so outfits might double as tents or be required to offer protection against disease or pollution.

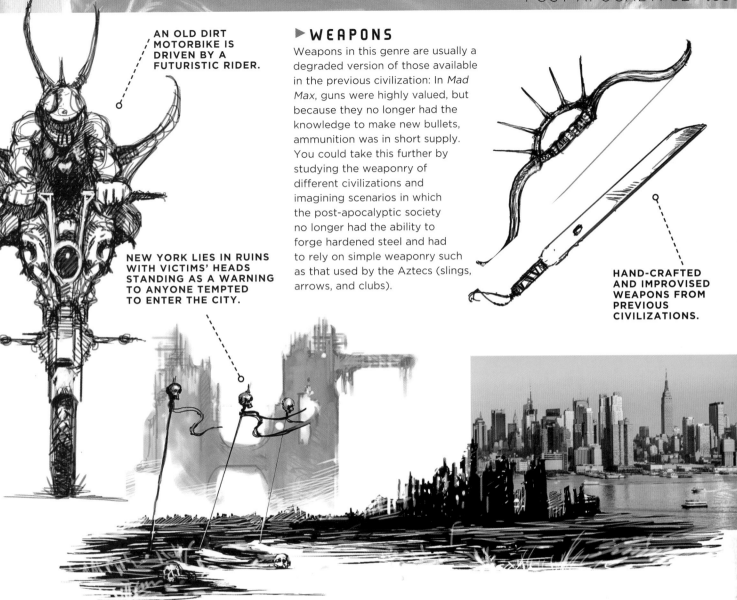

AN OLD DIRT MOTORBIKE IS DRIVEN BY A FUTURISTIC RIDER.

NEW YORK LIES IN RUINS WITH VICTIMS' HEADS STANDING AS A WARNING TO ANYONE TEMPTED TO ENTER THE CITY.

▶ WEAPONS

Weapons in this genre are usually a degraded version of those available in the previous civilization: In *Mad Max*, guns were highly valued, but because they no longer had the knowledge to make new bullets, ammunition was in short supply. You could take this further by studying the weaponry of different civilizations and imagining scenarios in which the post-apocalyptic society no longer had the ability to forge hardened steel and had to rely on simple weaponry such as that used by the Aztecs (slings, arrows, and clubs).

HAND-CRAFTED AND IMPROVISED WEAPONS FROM PREVIOUS CIVILIZATIONS.

▲ ARCHITECTURE

Study the ruins of old buildings and imagine how other societies might look after a downfall, depending on how the previous civilization met its demise. In the movie *Oblivion* the landscape itself had been radically changed, so only the tops of the largest buildings in Manhattan could be seen. Recent environmental disasters provide poignant references for a visual representation of our current civilization in ruins, but don't limit yourself to a scenario that follows the present day. You don't have to follow a linear timeline, but could have a medieval Chinese-looking culture followed by an ancient Mediterranean one, or take a futuristic scenario and replace it with a medieval or high fantasy successor.

▼ NATURAL WORLD

The general trend in fantasy art is to show a natural world that has been damaged or poisoned and is struggling to return. But it doesn't have to be that way. You could imagine a world where a tropical paradise has overgrown old cities or, as in the case of the movie *After Earth*, the natural flora and fauna has returned with a vengeance and evolved to defend itself against the depredations of humanity.

A HUMAN-SIZED, SHARP-TOOTHED VENUS FLYTRAP STANDS READY TO ATTACK PASSERSBY.

▶ PALETTE

You may be looking to build up layers of decayed manmade materials, such as steel, concrete, and glass, with a palette of grays, rusty reds, yellows, and browns, which would be contrasted with the fresh greens of new growth of emergent foliage. Avoid blues for skies and use less typical colors such as yellows, greens, or browns to suggest that an environmental change— or even disaster—has taken place.

It is the power of a single image to transport us into an entire reality, scenario, or genre that makes fantasy art so powerful in its effect on audiences. Here, we will look at the immense possibilities of the infinity of places that exist beyond time and space.

BEYOND TIME AND SPACE

Imagine a series of planets on which there are castles so large that they form a bridge from planet to planet. This idea was realized beautifully by Phillipe Druillet in an episode of his *Loan Sloane* comic series titles *Torquedara Varenkor: The Bridge Over the Stars*. And the floating rock islands of the movie *Avatar* were neatly explained by suggesting an area of the world where gravity was somewhat confused.

Cities in the sky have always been a great favorite among fantasy artists, but it doesn't need to stop there. If it's possible to place a castle on a cloud, you can push the boundaries of every element to create new scenarios such as a town where the buildings are pure fire (with some very strange inhabitants). Or you could try developing a temporal time paradox in which a character travels through time and affects the past or the future by doing so. You can use ideas like this to influence the setting of your artwork.

AN ALIEN EXPLORER POD MAKES ITS WAY ACROSS A DESERT PLAIN.

► **TRANSPORTATION**

Imagine taking a typical "sword-and-sorcery" kingdom but slightly increasing gravity. Machines and vehicles would then have to be built to a much stronger standard and everything would require the use of much lighter materials. Lightness and steadiness, not speed and weight, would now give combatants an advantage.

MANY TYPES OF WAR MACHINES MAKE THIS BATTLE BY PAUL BOURNE SPECTACULAR!

► **ARCHITECTURE**

Try distorting perspective from one side of your artwork to the other. For example, execute the top half of your drawing as though you are looking downward and the bottom half of the same drawing as though you are looking up. You can also try distorting buildings as if seen through a crazy lens and twist the edges of straight lines into fantastic curves to create a reality where the impossible becomes possible.

PLAY WITH PERSPECTIVE TO CREATE UNUSUAL BUILDINGS WITH UNEXPECTED ATTRIBUTES.

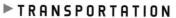

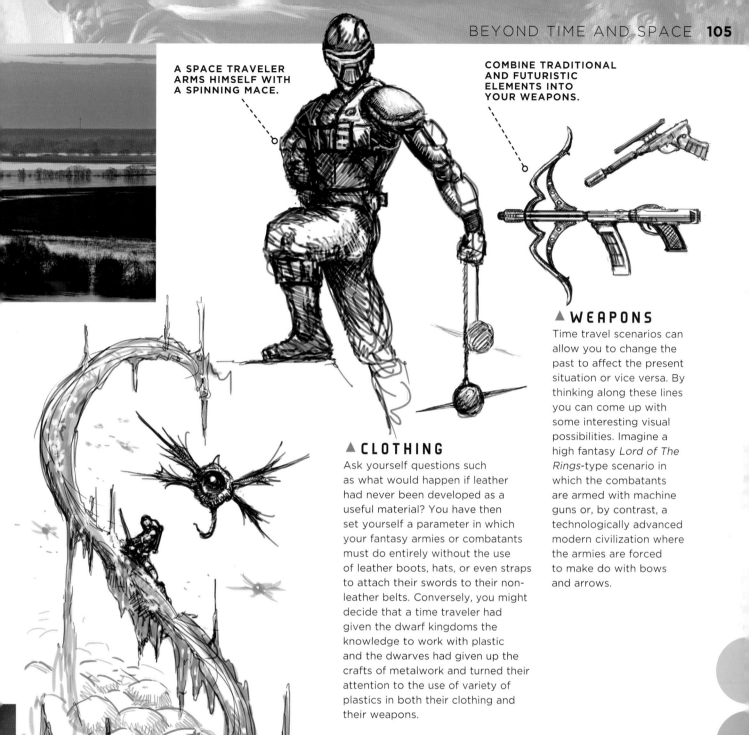

A SPACE TRAVELER ARMS HIMSELF WITH A SPINNING MACE.

COMBINE TRADITIONAL AND FUTURISTIC ELEMENTS INTO YOUR WEAPONS.

▲ WEAPONS

Time travel scenarios can allow you to change the past to affect the present situation or vice versa. By thinking along these lines you can come up with some interesting visual possibilities. Imagine a high fantasy *Lord of The Rings*-type scenario in which the combatants are armed with machine guns or, by contrast, a technologically advanced modern civilization where the armies are forced to make do with bows and arrows.

▲ CLOTHING

Ask yourself questions such as what would happen if leather had never been developed as a useful material? You have then set yourself a parameter in which your fantasy armies or combatants must do entirely without the use of leather boots, hats, or even straps to attach their swords to their non-leather belts. Conversely, you might decide that a time traveler had given the dwarf kingdoms the knowledge to work with plastic and the dwarves had given up the crafts of metalwork and turned their attention to the use of variety of plastics in both their clothing and their weapons.

▲ NATURAL WORLD

Environmental conditions may be given a temporal or material twist to add a new parameter to your fight scenes. Try setting yourself a "molecular" challenge, such as rock having a very low melting point causing mountains to turn into floods when the sun shines brightly, or water freezing as hard as steel and becoming the perfect material for making swords—but only in winter.

CHECK THESE OUT

In the graphic illustrations of M. C. Escher, you will find impossible buildings based on optical illusions with endless staircases that end up where they began and houses that defy the laws of gravity.

Temporal time paradoxes have been used to great effect in *Doctor Who* and *Futurama*, and it's good to note that the movie *Looper* used such an idea to provide a neat end to the story.

▶ PALETTE

You can find some interesting angles on creating new palettes: What if the sun were green? How would that affect all the highlights in your artwork? What if the sea were red? Would the sky still be blue? And what if blood were blue instead of red? How would that make your battle scenes look?

The fantasy sub-genres of hard fantasy, low fantasy, urban fantasy, magical realism and many others offer visions of worlds in which magical, supernatural and fantastic elements exist in settings that seem real, normal, and entirely believable.

MAGICAL REALISM

Such scenarios are very attractive to audiences because they offer a setting that seems familiar and that they connect with, but then adds a strange twist that is hard to explain or seems out of place. In Gabriel Garcia Marquez' book *One Hundred Years of Solitude*, the appearance of ghosts is treated as normal; this is one of the hallmarks of these genres. For artists, the normal, everyday setting amplifies the effect of the fantastic elements. The trick is not to create new worlds, but to introduce the magical into our world—something that many of us dream of.

Hard fantasy consists of creating new worlds, different from our own, but that are believable and logical, as in George R. R. Martin's *Game of Thrones*, and as such are less likely to have dragons, trolls, and fairies. Urban fantasy features a wide range of supernatural phenomena, which it incorporates within the familiar settings of cities or large towns. *Buffy the Vampire Slayer*, *Grimm*, and *Highlander* are all examples of this genre.

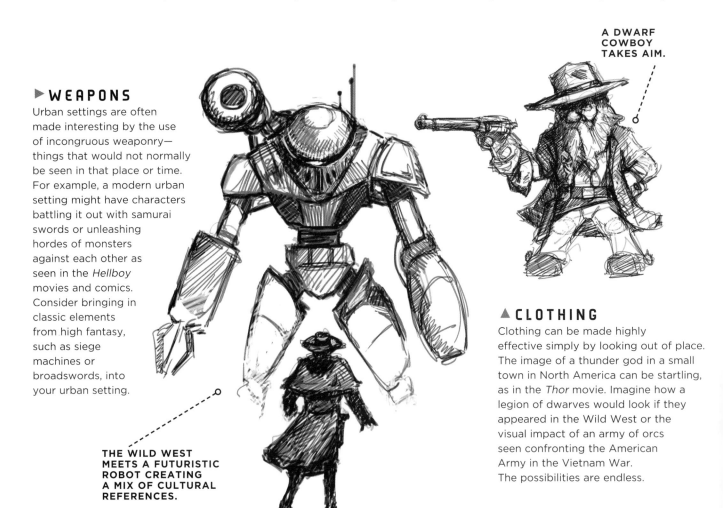

A DWARF COWBOY TAKES AIM.

▶ WEAPONS

Urban settings are often made interesting by the use of incongruous weaponry— things that would not normally be seen in that place or time. For example, a modern urban setting might have characters battling it out with samurai swords or unleashing hordes of monsters against each other as seen in the *Hellboy* movies and comics. Consider bringing in classic elements from high fantasy, such as siege machines or broadswords, into your urban setting.

THE WILD WEST MEETS A FUTURISTIC ROBOT CREATING A MIX OF CULTURAL REFERENCES.

▲ CLOTHING

Clothing can be made highly effective simply by looking out of place. The image of a thunder god in a small town in North America can be startling, as in the *Thor* movie. Imagine how a legion of dwarves would look if they appeared in the Wild West or the visual impact of an army of orcs seen confronting the American Army in the Vietnam War. The possibilities are endless.

▼ ARCHITECTURE

You have a choice of setting fantastical events in a real place (*Thor*) or setting realistic events in a fantastical place (*Game of Thrones*) so the architectural environment will have to go one way or the other, and it's important for you to be clear as to which route you are taking. If your setting is to be pure fantasy, then make sure that it is obvious to the audience!

A SEA SERPENT WINDS HIS WAY UP A STREETLIGHT.

A GIRL RIDES A LARGER-THAN-LIFE WOLF.

▲ TRANSPORTATION

Fantasy transportation will range from the classic vehicle types of horse-drawn carts (or any other beast for that matter) to interesting mixes of steampunk-style engine driven machines to strange hybrids that appear to be medieval but nevertheless defy gravity and float on air. The anime movie *Howl's Moving Castle* is a perfect example of just how far you can go with fantasy transportation. For combat vehicles you can try interesting mixes of modern tanks and aircraft crossed with ancient materials and weaponry.

▲ NATURAL WORLD

Urban settings do not necessarily have a great deal of vegetation and wildlife, but this is something you can use. The image of a lion in central New York in the movie *Twelve Monkeys* is a perfect example of this. Bringing real-world wild animals or fantasy creatures such as dragons or monsters, as seen in the movie *Cloverfield*, can emphasize the danger, threat, and excitement of your battle scene.

THIS ALIEN CASTLE REFLECTS ITS LEADER'S SINISTER NATURE.

▶ PALETTE

Real-life environments maintain all the colors of the real world. However, with all fantasy combat scenarios you will have the opportunity to add twists, such as lightning strikes where they simply don't belong or brightly colored buildings when they should be dull-colored concrete and steel—all of which will add variety to your images.

CHECK THESE OUT

You will find magical realism in movies such as *Amelie*, *Midnight in Paris*, or *The Green Mile*. Classic examples of realistic fantasy include *Pinocchio*, *Five Children and It*, and *The Borrowers* (left). Stories such as *Harry Potter*, *Discworld*, and *American Gods* all have one foot in reality, but also use completely fantastical scenarios in a "world-within-a-world" setting.

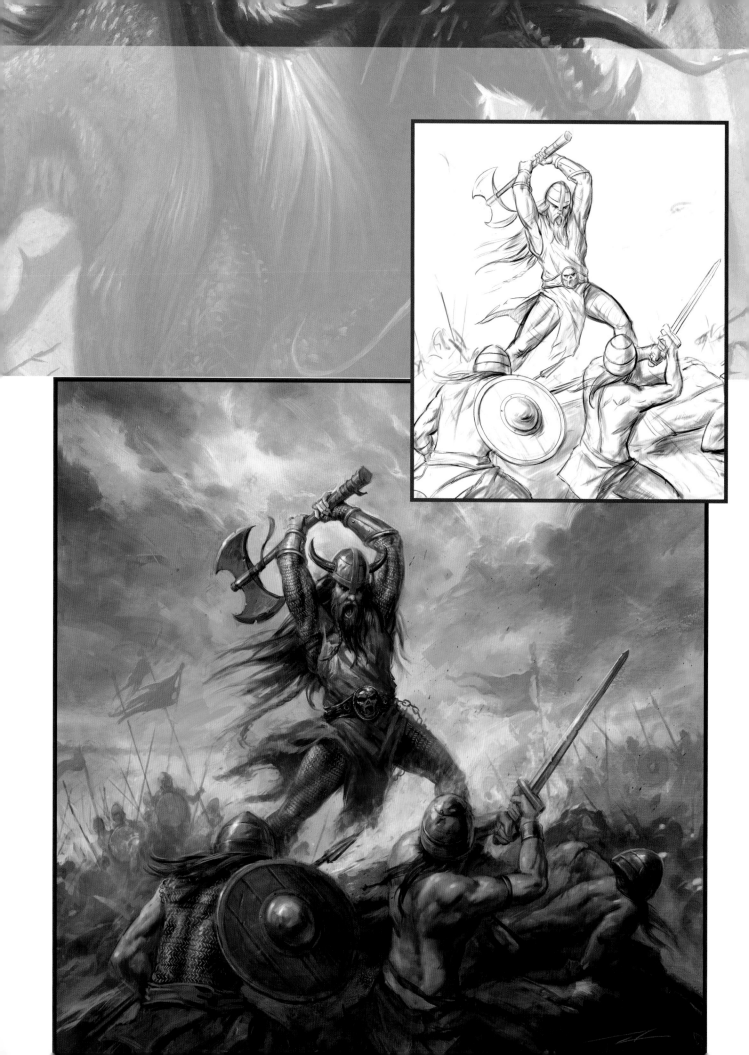

ARTISTS AT WORK

5

"I firmly believe that any man's finest hour, the greatest fulfillment of all that he holds dear, is that moment when he has worked his heart out in a good cause and lies exhausted on the field of battle—victorious."

Vince Lombardi (1913–1970)

Fantasy combats provide huge scope for creating some of the most exciting paintings possible, and nothing beats a dragon going toe-to-toe with some heroes over its treasure horde. Having decided on the subject, I decided to give it a subtle twist by placing the scene within a dank swamp and make the dragon green to tie in with its habitat.

ARTIST BIO
I was ten years old when my teacher read *The Hobbit* to my class, this awakened my imagination to the realms of fantasy, which in turn was channeled by my discovery as a young teenager of the game of Dungeons and Dragons. My drawings and painting all now revolved around heroes, monsters, and their dramatic encounters. I maintained this passion into my college days, creating and contributing to fanzines along with the occasional professional assignment. As I came to graduate, I decided to try to make that passion into my career. I am now an established artist within the games industry.

RALPH HORSLEY

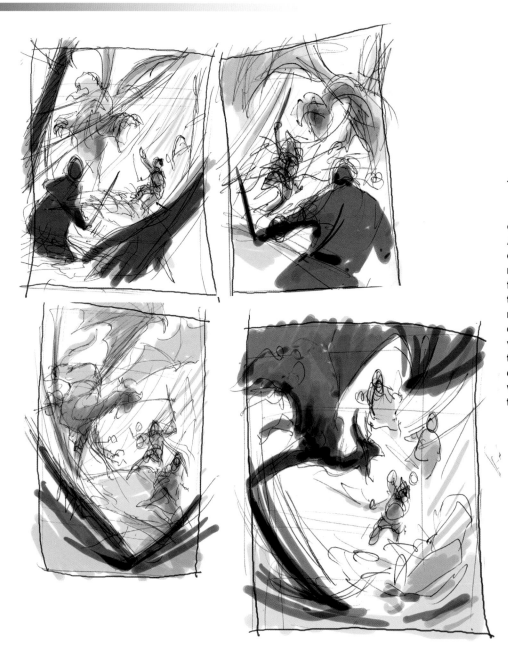

1 **I planned the picture through a series of quick "thumbnails."** In each sketch different compositions were tried. A different mood is evoked depending on how our view relates to the action. The large figure in the foreground makes the heroes feel stronger and more powerful. When we look down on them, they appear more vulnerable and threatened. In this case, I liked the idea of the dragon swooping in from top left, with the heroes isolated amongst the trees upon the treasure pile.

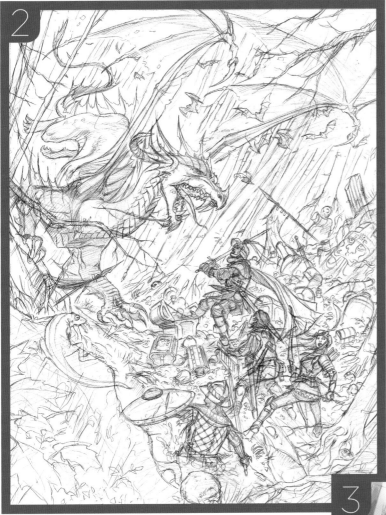

2 I then needed to work up the chosen idea. Whether working traditionally or digitally, I like to sketch in graphite onto board. This is the foundation of the painting and I spend a lot of time making sure that I am happy with the drawing. I expanded the number of characters to four to allow me to bring in more storytelling.

A SOFT PENCIL IS GREAT FOR SHADOW AND TONE, WHILE A HARD PENCIL IS PERFECT FOR DEFINING DETAILS.

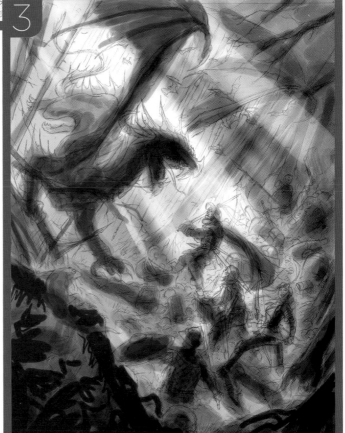

3 Having finalized the line sketch, I scan the image and create a digital tonal value sketch. At this stage, I am working out the lighting and how the key elements will interact to provide depth and focus to the picture. I am unconcerned with the colors, just the lights and darks. The main shaft of sunlight silhouettes the dragon nicely, making his form read strongly and dynamically, while the spotlight falls on our first knight.

BY CREATING A LIGHTING SKETCH I PROVIDE MYSELF WITH A CLEAR "ROAD MAP" OF LIGHT AND SHADOW TO WORK TO, SAVING ME PROBLEMS LATER ON.

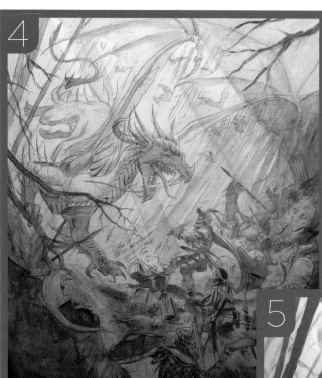

4 The next stage is to block in the base colors. I had already decided on a color scheme of greens and oranges. At this stage I can see how the image is taking shape, and can adjust the general palette if necessary.

5 Next, I prime the surface of the board to fix the graphite and prepare it for my paints, by applying an underpainting in acrylics. This follows the same forms as the tonal value sketch and gives me the option of applying oil paints thinly as glazes or more opaquely.

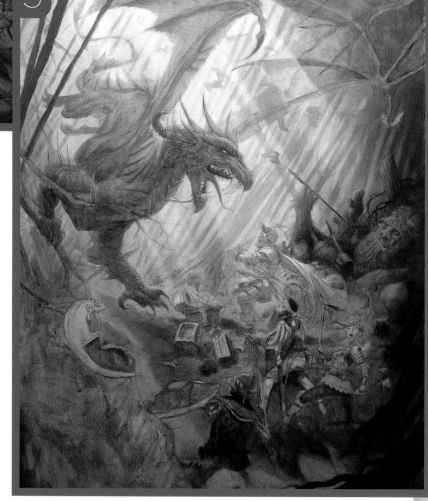

6 In the final artwork you can see how the tonal values throughout the painting have been evened out to a range of rich sepia, yellows, and greens with the blues reduced. All the elements of the painting have been carefully blended together so everything appears to sit comfortably in the scene without any one element sticking out too much. There is no limit to the amount of time you can spend refining the final art—it's up to you to decide when to stop!

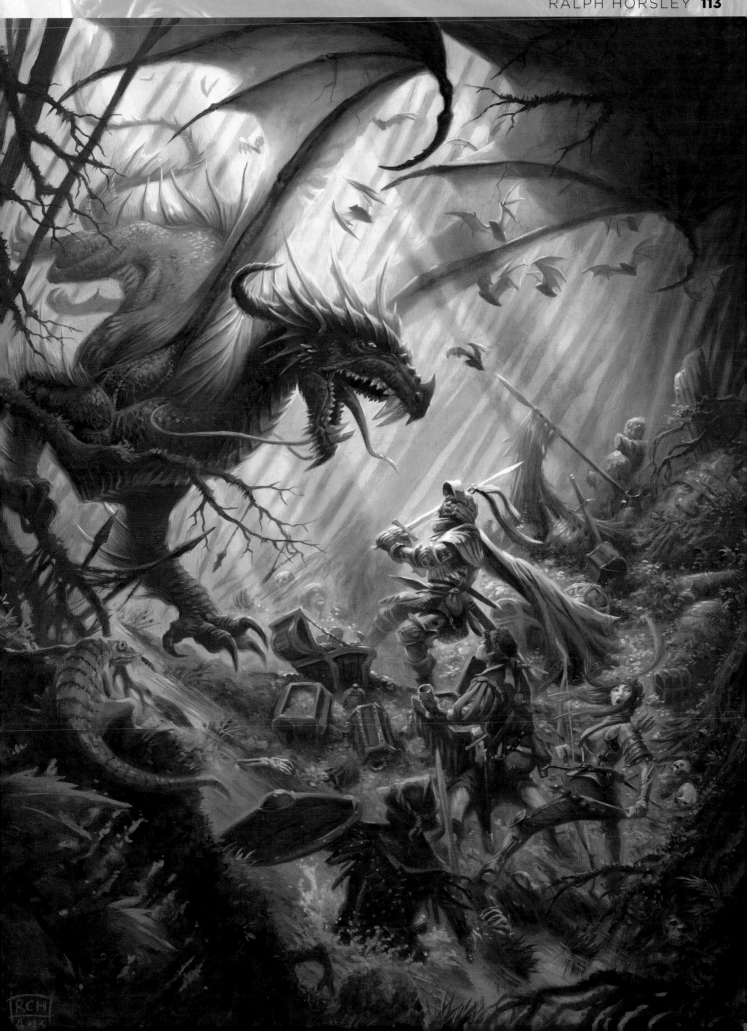

This piece is based on a scene from the legend of Robin Hood in which one of the Merry Men is rescued from the scaffold. Our hero and his allies have just swept onto the scene, shot the executioner, and freed their friend. Now they have to fight their way out!

MATT STAWICKI

ARTIST BIO
I think I have to trace my love of fantasy back to the Saturday morning superhero cartoons. The idea that man could fly or possess super powers was captivating. I started drawing the heroes as a young boy and became more fascinated as I grew. I discovered Conan, and the works of Frank Frazetta, and, like every other kid at that time, I was blown away by *Star Wars*! All of this affected my interests— and, of course, what I drew.

1 **After several rough doodles, I produce a final sketch in which all the main compositional elements are worked out: The size and positioning of the characters; the setting; and the story I am telling with the image.**

2 **Before beginning work on the final painting, I do a value study in which I work out the tonal range of the painting. Basically, I analyze how the light and shadow fall and how much contrast should appear in the painting, as well as playing around with some character, costume, and setting details.**

3 The underpainting is an important part of the process that allows me to lay down the basic building blocks of the image. I like to use burnt umber for this stage, as it lends a warmth and depth to the final painting.

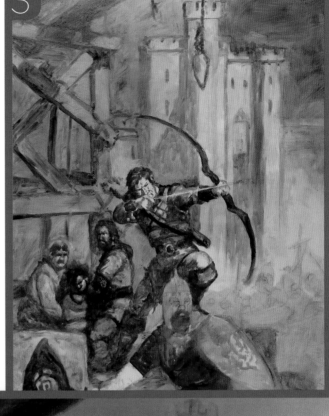

4 In the finished underpainting I establish all the main colors and values. All the main compositional elements such as the characters and setting are in place, but I haven't started work on the details yet.

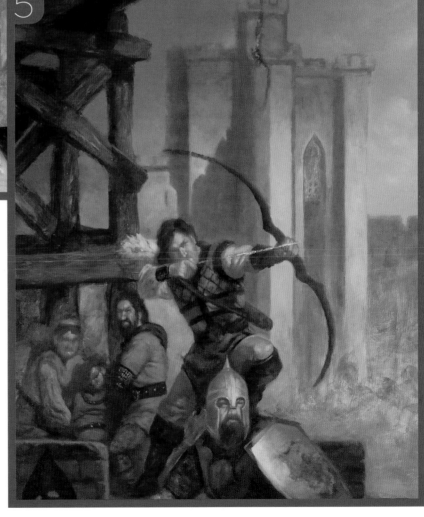

5 In these early stages, I allow myself to keep things loose. There is still plenty of scope to experiment and see what works and what doesn't. Elements of the artwork can be painted over or removed altogether.

6 Next, I get to work on refining all the elements simultaneously, bringing each area into more detail in parallel with all the others. The background gets as much attention as the characters at this stage. You can see that the fine details of costume, faces, and so on, are still applied with broad strokes.

7 Now the foreground figures start to get some serious detail treatment, and I do further work on the middleground figures, too. I make a major change to the lighting in the sky behind the castle, which has quite a significant impact on the overall look of the painting.

8 I spend a lot of time working back into and refining the main areas of focus. Although every element of the artwork has been made stronger and clearer, you will see that the key figures are given particular emphasis.

9 For the final painting I make some digital color adjustments, which is a great option for artists working in traditional media, as well as those who prefer to work entirely digitally.

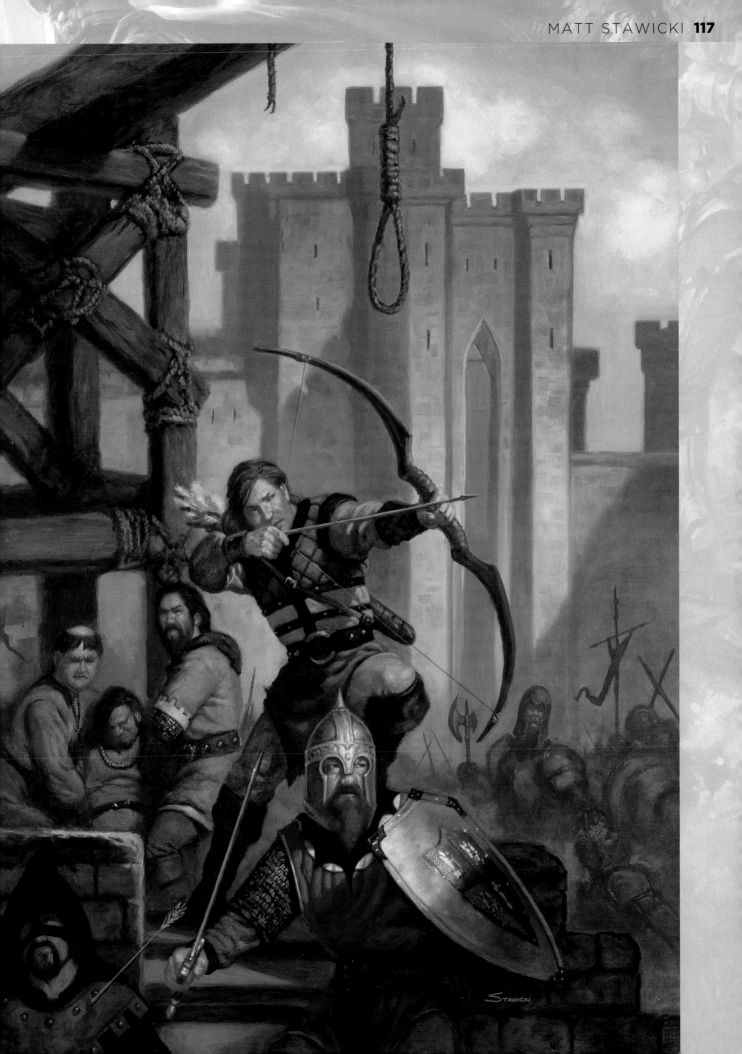

This image was commissioned for a CD cover by a heavy metal band. The provisional title was *Night of the Ax* and the description was simple: A heroic warrior on a battlefield dispatching his foes with an ax. They wanted something striking that would grab the viewer's attention. These days I work entirely digitally, mainly for speed and the ability to correct mistakes with ease, but my methods and approach are the same as when I worked with traditional media.

ARTIST BIO
Alan Lathwell is a freelance illustrator based in the UK. He specializes in fantasy art and has a passion for mythology and an interest in ancient warfare. His paintings have been used to illustrate books, CD covers, role-playing games, and collectable cards. His book *Warriors & Heroes* outlines the methods and techniques he uses to create his images.

ALAN LATHWELL

1 **I always begin my pictures with a very loose pencil drawing,** not worrying about details at this stage and focusing on poses and composition. Keeping my lines free and fluid, I quickly hit on a pose for the main figure and built a classic triangular composition with him at the apex.

KEEP INITIAL PENCIL LINES FAINT TO MAKE THEM EASIER TO ERASE AND MODIFY.

2 **Once I'm happy with the rough sketch,** I carefully redraw the figures, adding detail and erasing unnecessary lines as I go. I also decide where my light source will come from (in this case top left) and loosely indicate some shading to give form to the drawing.

REINFORCE THE DRAWING WITH DARKER LINES WHEN YOU ARE HAPPY WITH THE SKETCH.

3 I rapidly block in flat areas of color using large brushes and making sure the color shapes work well and harmonize together. In this case, I imagined the scene taking place at sunset with the sky lit by the fires of battle, so I chose a red/orange color scheme.

BRUSHSTROKES CAN ADD MOVEMENT AND VITALITY TO A PICTURE.

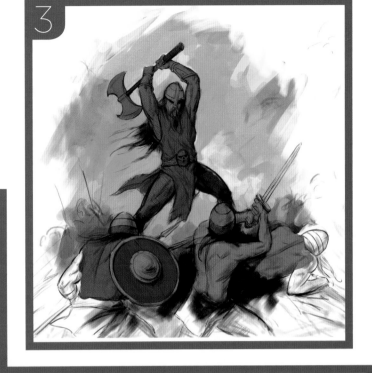

4 Over the flat washes of color, I loosely indicate the lights and shadows on the figures, continuing to keep the direction of the light source in mind. I always try to see the picture as a whole, letting the large shapes and masses decide what is needed to make a balanced composition.

CHOOSE YOUR WEAPON!

The weapons with which you arm your warriors can reflect their personality and culture, so choose them carefully. For example, an ax or basic club are usually the weapons of choice for brutal, barbaric types, while a well-crafted sword with a jeweled hilt could indicate a wealthy, sophisticated character.

5 With the underpainting complete, I'm ready to bring the image to a tighter finish and start on the background. In this image, I wanted the sky to reflect the chaos of the battle, so I tried to create interesting cloud shapes with plenty of lively brushwork to help guide the viewer's attention to the main focal point.

LOOSELY DRAWN AND FADED BACKGROUND FIGURES HELP TO SHARPEN THE FOCUS ON THE MAIN ACTION.

6 At this stage I start to bring the figures to life, beginning with the hero. Using a small brush, I laid down the darker tones on the face and helmet first. Next to these I put the mid tones and carefully blended and modeled the forms before dabbing on the brighter highlights. I redrew the features with a small detail brush.

NOTE HOW DIFFERENT MATERIALS REFLECT OR ABSORB LIGHT.

7 Continuing to work on the main figure, I moved on to the arms and ax, starting with the shadows and working up to the lights. I painted his hair flowing wildly around him to give a sense of movement and decided to add horns to the helmet to add a classic fantasy touch!

8 I then worked up the foreground figures, keeping their colors muted so they don't steal the limelight from the hero. When a painting is finished, I look at the image as a whole and make any final tweaks that I feel are necessary.

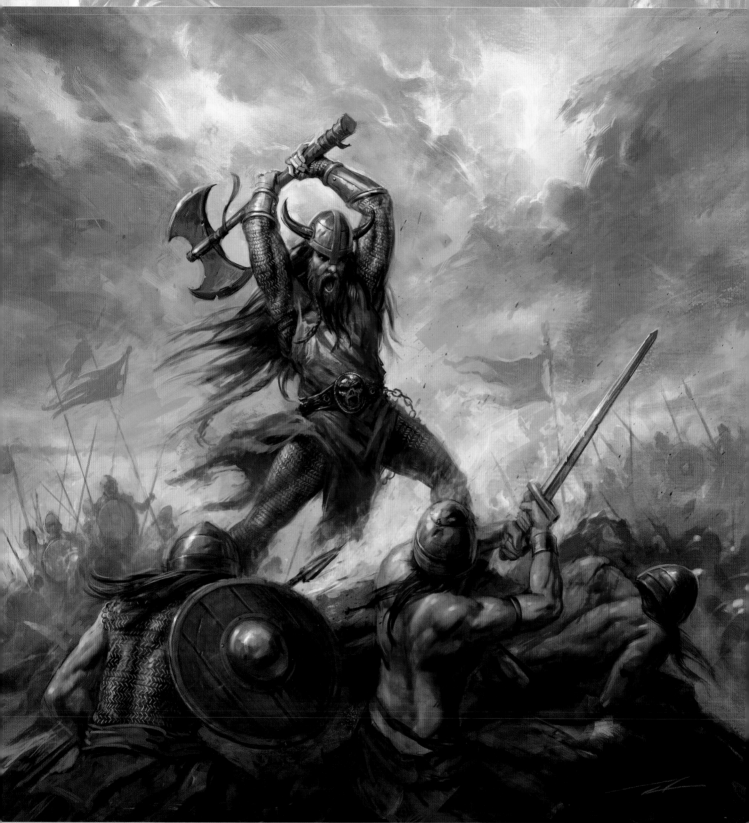

9 However clear your original vision, a painting can go in any direction during the creative process, and the artist's job is to steer it down the right path, or at least to keep it on the road! On the whole, for this project the final picture is true to the image I had in my mind. I believe it captures many of the key elements that make a successful painting, a balanced composition with a well supported focal point, a sense of depth, and a harmonious color scheme.

For this piece I decided to paint a warrior about to enter into battle, at a moment of calm before the storm. Initially, I had envisaged a battle-hardened knight striding in from a dusty haze, but that particular notion didn't last for long as my knight was soon transformed into a fiery-haired swordswoman.

ARTIST BIO
I've drawn for as long as I can remember. First it was dinosaurs, then robots. That kept me busy for several years, until I reached the sixth grade, when comic books and old Conan paperback novels (with covers by Frank Frazetta) drew me into fantasy art. I've been following that path now for nearly thirty years, working professionally for half that time.

PHROLIAN GARDNER

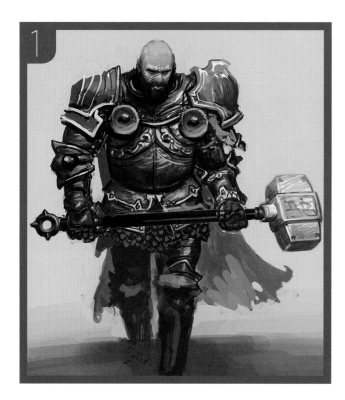

1 My original studies for the painting depict a knight striding purposefully toward the viewer from a dusty haze. I was mostly interested in depicting the beaten-up armor, which suggests the warrior has been engaged in a long quest or war.

2 I continued to explore various possibilities for developing the character, such as making the knight younger and less world-weary.

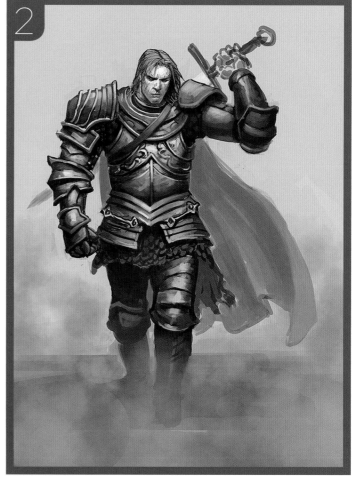

3 Finally, I decided to try a completely different approach as I hadn't painted a female character for some time. This early digital sketch focuses on the face and hair to establish the personality of the character while the pose is loosely executed with quick, broad strokes.

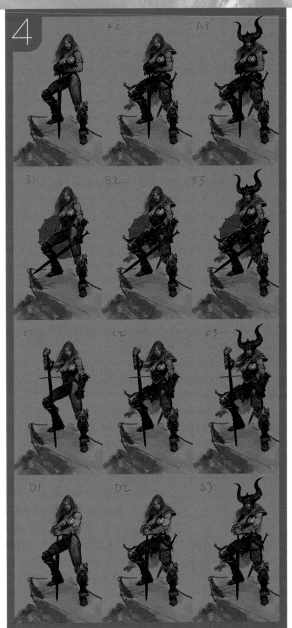

4 One of my favorite parts of the process is exploring the many and varied options we have for armor, and to work out the detail of the pose. Although the pose is fairly constant, each of the different arm positions I tried had a huge effect on the overall impact of the image. I like to take plenty of time to work out all the details at this stage, so I can be confident that I know exactly what I am aiming for with the final painting.

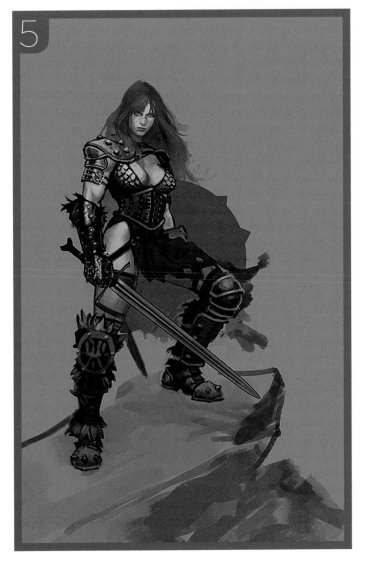

5 For the initial color application, I used thick brushes and put in the main areas of light and shadow to produce clear, strong forms. Although most details were quite loose at this stage, I focused in on the expression on the face, as I was very clear in my mind as to how I wanted this to be: calm and confident, but deadly, too.

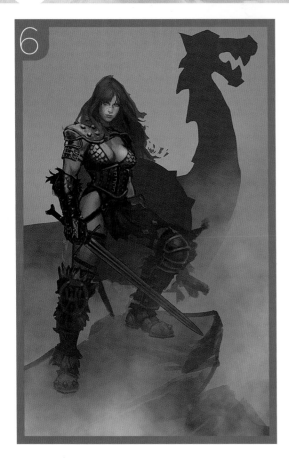

6 I decided on the dark, desaturated blue of an early morning foggy shoreline for the base color of the scene, which I executed as an overlay. This narrows the overall tonal value of the painting to somber hues of dramatic blue. I then darkened the entire picture. Initially, I had the idea of using a Viking longship as an interesting background element, so I threw down a quick silhouette.

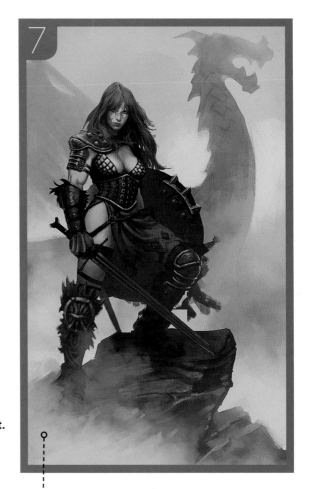

7 I then started taking the color values from dark to light with successive sweeps of detail. At this stage all the main elements are much more refined, with less detail on the background areas. This has the effect of concentrating the viewer's attention on the most important part of the painting—the figure. The Viking longship has taken on the appearance of looming out of the mist.

EVEN THOUGH THE ARTWORK IS AT AN ADVANCED STAGE, HUGE CHANGES TO LIGHT, COLOR, DETAIL, AND EVEN THE BACKGROUND CAN STILL BE MADE.

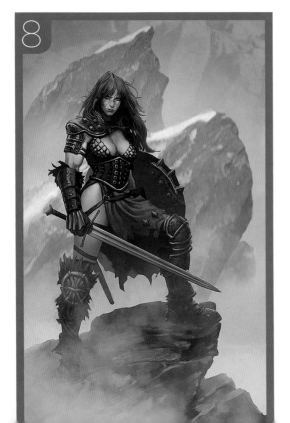

8 In the end I dropped the Viking ship from the background in favor of snowy rocks. I continued to work on the figure, making pose adjustments where they would tighten the overall dynamic. And I continued to make color changes. Careful consideration of color values helps to guide the viewer's eye and also to define spatial relationships. Small, seemingly insignificant final touches can increase the overall impact of a painting; I added a few floating strands and some braiding to the hair, which creates a further dimension.

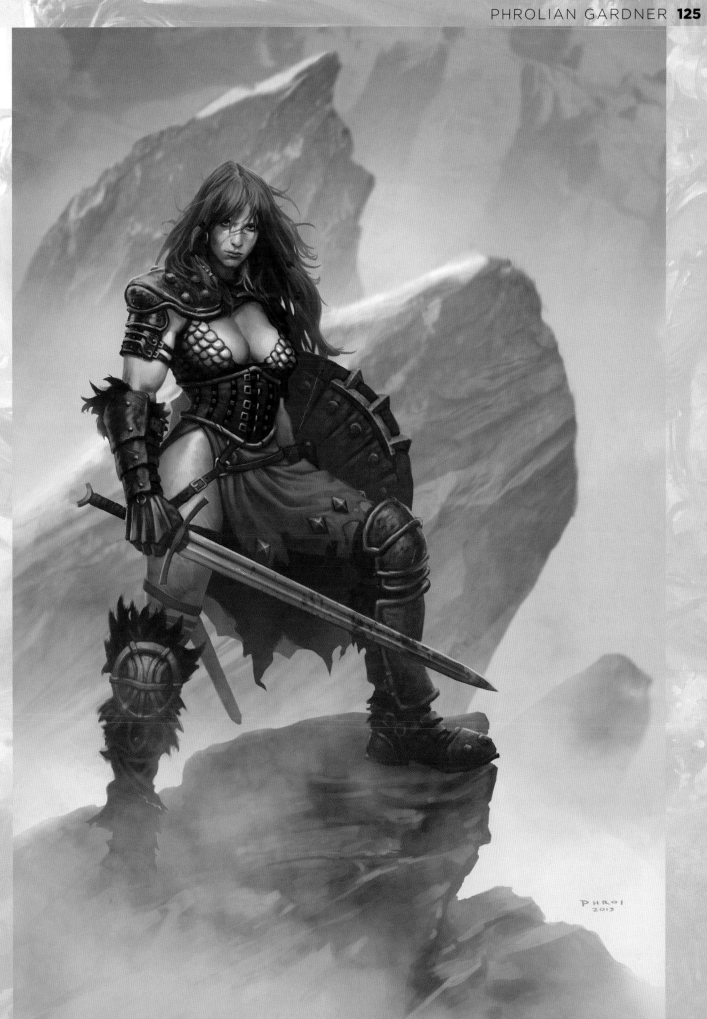

INDEX

CREDITS

Quarto would like to thank the following
agencies and manufacturers for supplying
images for inclusion in this book:

Alamy, p.15tl, 99tr, 102bl, 107bl
Banana Republic images, Shutterstock,
 p.98bl
Bourne, Paul, paul@contestedground.co.uk,
 p.104br
Calvetti, Leonello, Shutterstock, p.97tr
Cichawa, Rafal, Shutterstock, p.98cr
Corbis, p.34c/b
Cortes, Fernando, Shutterstock, 106–107tc
Cowan, Finlay, p.8, 10–11t, 12–13, 15tr, 16, 19br,
 27, 29r, 36, 38–48, 49l, 50–53, 90
Gardner, Phrolian, http://phroilangardner.
 blogspot.co.uk/, p.122–125
Getty Images, p.97br
Gustilo, Anton, www.antongustilo.com, p.35b
Hidalgo, Pablo, Shutterstock, p.96cr
Horsley, Ralph, www.ralphhorsley.co.uk,
 p.2, 110–113
Karas, Panos, Shutterstock, p.15br
Klimov, Igor, Shutterstock, p.22
Krzeslak, Piotr, Shutterstock, p.101bc
Lano, Angelo, Shutterstock, p.101tc
Lathwell, Alan, http://alanlathwell.cgsociety.
 org/gallery/, p.106, 118–120
LightWave, www.lightwave3d.com, p.22b
Liseykina, Shutterstock, p.104–105tc
Ljunggren, Daniel, http://darylart.com,
 p.35c, 86–87
McCambridge, John, http://mccambridge.
 cgsociety.org/gallery, p.10, 19t, 26, 61t, 84l
Minnaar, Raymond, www.raymondminnaar.
 co.za, p.28cr, 35t, 56t, 70c
Netiaga, Vitaliy, Shutterstock, p.15bl/c
OPIS Zagreb, Shutterstock, p.100b
Painter 12, www.corel.com, p.22b
Peterson, Joe, p.23tr
Photoshop, www.adobe.com, p.22b
S.Borisov, Shutterstock, p.103cr
Sabod, Nicram, Shutterstock, p.95tr
Saunders, Jason, Shutterstock, p.95tc
Sharp, Liam, p.20
Springborg, Jonas, www.springborg.
 blogspot.dk, p.23b
Sturgolewski, Radek, Shutterstock, p.94b
Totajla, Shutterstock, p.15t
Yeliseyev, Nikolay, http://nikyeliseyev.
 blogspot.co.uk, p.49r, 78l, 79t, 92

All other artworks are by Matt Stawicki

All step-by-step and other images are
the copyright of Quarto Publishing plc.
While every effort has been made to credit
contributors, Quarto would like to apologize
should there have been any omissions or
errors—and would be pleased to make the
appropriate correction for future editions
of the book.